IMAGES
of America

SEATTLE'S
GREENWOOD-PHINNEY
NEIGHBORHOOD

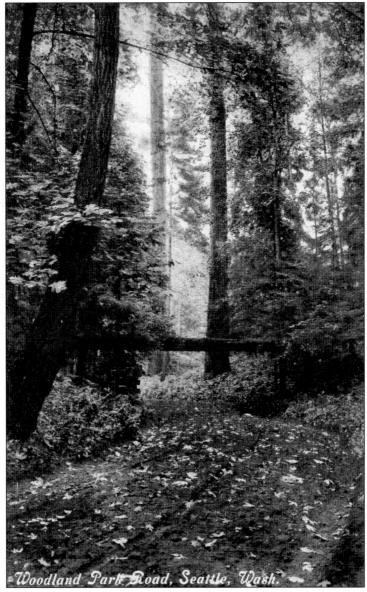

Woodland Park Road, Seattle, Wash.

Much of western Washington was once covered with forests of cedar, fir, hemlock, spruce, and other trees. For thousands of years, native peoples lived in and near the forests without depleting them. Later settlers saw the trees mainly as a source of income to be cut into lumber and shipped away. This photograph shows a stand of ancient trees in western Washington. The ground is covered with branches and twigs, which were blown down from above.

ON THE COVER: This is the intersection at Eighty-fifth Street and Greenwood Avenue looking west from Eighty-fifth Street in June 1940. By this time, Bolton's Lunch, on the left, had ceased being the interurban's waiting room. The Phinney streetcar is waiting for a starter to guide the trolley pole and car across Greenwood. In 46 years, Eighty-fifth and Greenwood had not seen much significant change. The streetcars would soon be gone. By the end of 1940, bus routes would terminate at 145th Street. (Phinney Neighborhood Association.)

IMAGES
of America

SEATTLE'S GREENWOOD-PHINNEY NEIGHBORHOOD

Ted Pedersen

ARCADIA
PUBLISHING

Published by Arcadia Publishing
Charleston SC, Chicago IL, Portsmouth NH, San Francisco CA

Printed in the United States of America

Library of Congress Catalog Card Number: 2007927748

For all general information contact Arcadia Publishing at:
Telephone 843-853-2070
Fax 843-853-0044
E-mail sales@arcadiapublishing.com
For customer service and orders:
Toll-Free 1-888-313-2665

Visit us on the Internet at www.arcadiapublishing.com

This book is dedicated to the memory of my parents who brought me to this wonderful neighborhood where I was lucky to grow up so long ago. And to all of those who have been fortunate enough to have lived in and loved this community.

CONTENTS

ACKNOWLEDGMENTS

A book like this can never be accomplished alone, so thanks go out to everyone who helped in the process. First my thanks to the always helpful faculty of Greenwood Elementary School and in particular those students of grades five, six, and seven who, in 1948, researched and collected first-hand information from many long-term residents and wrote "A History of Greenwood," which they initially presented as a pageant.

Many thanks to the wonderful staff of the Greenwood Public Library for providing information and photographs: Beth Kashner, Peg Dombek, Mike Bergson, Heather Card, Marty Hendley, Kathy Teufel, and Francessa Wainwright. To Beth Pflug of the Seattle Department of Neighborhoods and the Greenwood-Phinney Chamber of Commerce. To the ever-helpful folks at the Seattle Municipal Archives, the University of Washington (UW) historical collections, and especially to Carolyn Marr of the Museum of History and Industry (MOHAI). And, of course, thanks to the Phinney Neighborhood Association and in particular to Ann Bowden for background material and many wonderful images. And thanks to everyone who recalled their experiences of growing up in this neighborhood. Thanks to Marlene of Gordito's for the loan of some wonderful old photographs. Certainly, thanks goes to my wife, Phyllis, my sisters Sally and Peggy, and my cats, Rookie and Charlie, for their support in the writing of this book. And finally, of course, to my editor, Julie Pheasant-Albright.

All photographs not otherwise credited are from the author's collection.

INTRODUCTION

"Greenwood, what a beautiful name. It brings to you a picture of green woods, paths fringed with fern and moss and quiet little nooks. It suggests the forest with lofty fir, cedar and blooming dogwood." So began the students of Greenwood Elementary School as they wrote "A History of Greenwood" as their 1948 class project. And they got it exactly right.

In the beginning, Greenwood was once just that: a lush and green forest stretching across low rolling hills and shallow ravines with no discernible boundaries or borders. The area had small streams that were full of fish, and the forest held an abundance of wildlife. This natural state did not remain for long. Late in the 1890s, loggers came to the area and established two lumber mills. Every Friday night the loggers would head for the city of Ballard to the southwest of Greenwood for beer and fun.

The main attraction to the Greenwood area may have been its cemetery. The cemetery was laid out by David T. Denny in 1891 on 40 acres bordering West Eight-fifth Street and Woodland Avenue, and was designed to be a large cemetery. The secretary for the cemetery corporation was the same H. R. Clise who was the secretary for the Mount Pleasant Cemetery on Queen Anne Hill. Thus it seems plausible that Greenwood was intended as an expansion for that cemetery located outside of the then-Seattle city limits to avoid the restriction on new cemeteries within the city. Directly to the west was a 40-acre parcel of land for a school. The cemetery, which in 1903 became known as the Greenwood Cemetery, was sold in 1907 to former state governor Henry McBride for $75,000. He immediately platted a one-eighth section into residential lots and called his development "the Greenwood Park Addition." During the cemetery's 17-year existence, few bodies were interred on the grounds, making removals to the city of Ballard's nearby Crown Hill cemetery relatively easy. Some records indicate that this cemetery was also known as the Woodland Cemetery and that Greenwood Avenue was named for the cemetery.

The area south of Greenwood got its start thanks to Guy Carleton Phinney, a wealthy immigrant from Nova Scotia, who emigrated from Canada to the Puget Sound area in 1881. After making a fortune in downtown Seattle real estate and the lumber and insurance businesses, Phinney decided to build a traditional English estate on 200 acres of wooded forest. The neighborhood was and remains largely a bedroom community that on the east spills down the spine of Phinney Ridge to Green Lake's shores. On the west it runs to the edge of Ballard at Eighth Avenue NW. It runs north from North Fiftieth and Market Streets out to about North Eightieth Street, depending on who is asked. Phinney residents lay claim to Woodland Park Zoo and its four-footed residents, which have influenced the direction of the community over the years. ·

Both communities have, over the decades, shared a common concern: how to adequately define themselves. They have at times been called Seattle's forgotten neighborhoods. Phinney is the place where the Woodlawn Park Zoo is located, and Greenwood is a quaint little neighborhood where nothing much ever happens. To be certain, the last 100 years have not brought about dynamic changes in either community. But together they have forged a common bond perhaps best illustrated by the formation of the combined Greenwood-Phinney Chamber of Commerce.

They share residents with long-standing commitments to their community, host a world-class zoo, and are home to the only Tibetan Buddhist monastery in the world outside of Tibet.

And, on a personal note, the author recalls what it was like growing up here and hopes that these photographs will bring back fond memories to those who live or have lived there.

Welcome to Seattle's Greenwood-Phinney neighborhood.

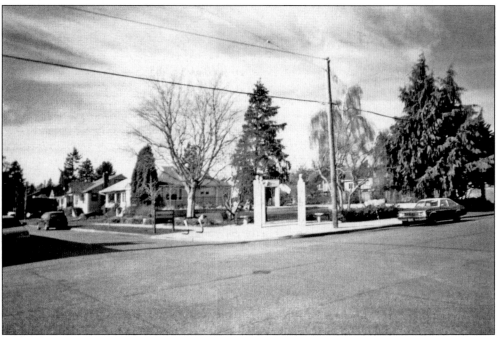

This park at the corner of Sixth Avenue and Seventy-sixth Street NW, two blocks from where the author grew up, symbolizes the friendly, family-oriented neighborhood that Greenwood-Phinney has come to represent.

One

TAMING THE LAND

Land could not be purchased from the federal government until it was surveyed. So on August 17, 1855, a survey crew proceeded north along what would later be defined as Greenwood Avenue N starting at North Sixty-fifth Street. They noted fir and cedar trees from one and one-half to three and one-half feet in diameter. At Seventy-sixth Street the crew spotted a dead fir nearly six feet in diameter. Upon reaching Eighty-fifth Street, they described the route along this mile as follows: "Land nearly level, Soil 2nd rate. Timber, fir, cedar, hemlock. Undergrowth: Laurel, Fern and willow." They submitted their completed survey on January 11, 1856.

On June 28, 1872, William Knight purchased 159 acres from the federal government in what would become a part of the Greenwood retail district of Seattle. The Greenwood district is located in north Seattle, north of Green Lake. Knight paid $1.25 per acre for the real estate. His purchase included land that would later be bounded by Eightieth to Eighty-fifth Streets and Third Avenue NW to Aurora Avenue, plus Eighty-fifth to Ninetieth Streets and Greenwood to Fremont Avenues. The land northwest of Northwest Eighty-fifth Street and Greenwood Avenue N was set aside for school purposes.

In 1900, most of Phinney Ridge was still forest. But within three years, the eastern slope had surrendered its Douglas fir and cedar trees to Parker's sawmill at the east end of Green Lake, and 1,500 residents now lived on the balding ridge above the lake's western shore. Certainly, rail travel was easier than slogging through mud roads in the early automobiles. The pattern of growth of the Phinney neighborhood thus followed the laying of rails for the electric trolley lines in the area. By 1900, nearly all the land in the future Green Lake, Phinney, and Greenwood neighborhoods was platted. But development on the western slope of the ridge, facing Ballard, lagged behind the eastern slope, facing Green Lake.

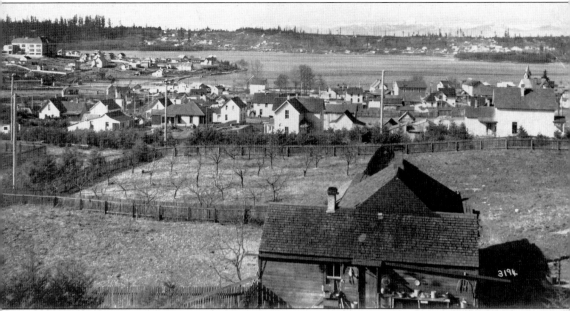

Beginning in 1888, electric streetcar lines were being built in many parts of Seattle. The Green Lake Electric Railway was begun in 1889 to serve the area north of Fremont. The tracks followed an old logging railway route and ran along the eastern shore of Green Lake, ending at about North Seventieth Street. This late 1890s photograph by Anders Wilse shows the tracks of the Green Lake Electric Railway running along the shores of Green Lake. It looks as if the trees had been cut recently. (Phinney Neighborhood Association.)

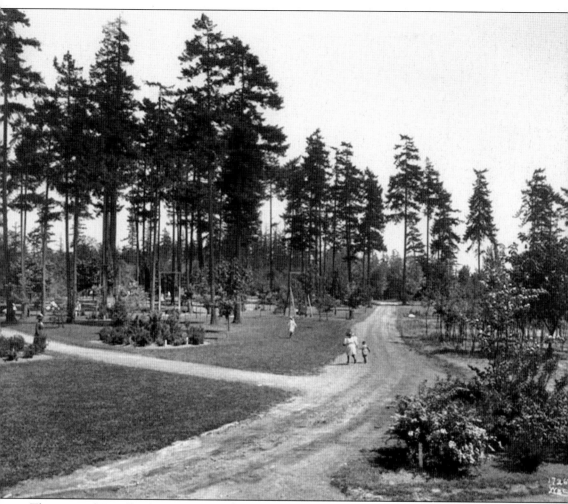

This view of Woodland Park from an early postcard from about 1890 shows a woman and child walking along one of the roads that cut through the park. Note how many of the trees have been cut, leaving large clearings.

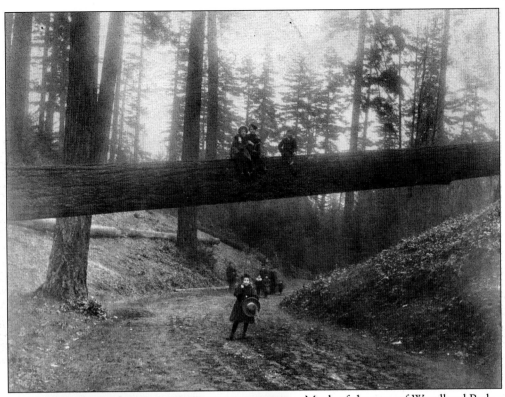

Much of the area of Woodland Park was logged before 1890, but loggers left the smaller trees—everything 6 feet in diameter or less. This created many small paths for people to use. One such path can be seen in this early postcard.

Woodland Park during the 1890s had gardens, a zoo, a large greenhouse, and many miles of winding paths through the woods. At that time, Woodland Park included Green Lake. This postcard, taken sometime between 1897 and 1900, shows children playing on the road to Green Lake in Seattle's Woodland Park.

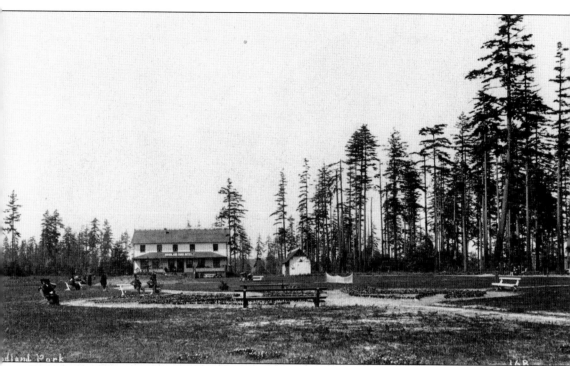

In 1887, a wealthy lumber mill owner and real estate developer named Guy C. Phinney paid $10,000 for 342 acres of land along what is now called Phinney Ridge and down the slope to Green Lake. This photograph shows part of his elaborate estate. Phinney spent $40,000 constructing an elegant English-style estate, complete with formal gardens. He named it Woodland Park. (University of Washington special collections.)

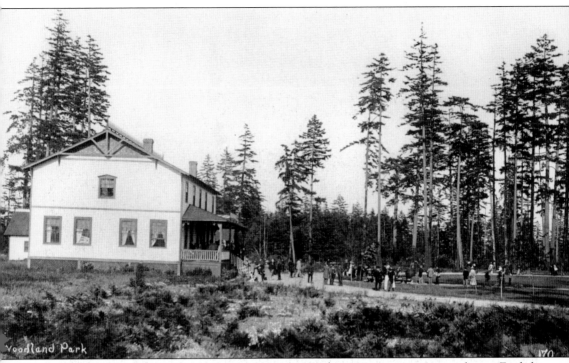

Woodland Park

Guy C. Phinney kept 180 acres for himself and spent $40,000 constructing an elegant English-style estate, complete with formal gardens. There was a conservatory, promenade, hunting lodge, the Woodlands Hotel, and even a menagerie. The animal collection featured North American animals such as black bears and deer, but there were African ostriches as well. The upper portion, where the zoo is today, was almost completely cleared of trees. A winding road led down to the lake's edge through the more forested portion of the estate. (University of Washington special collections.)

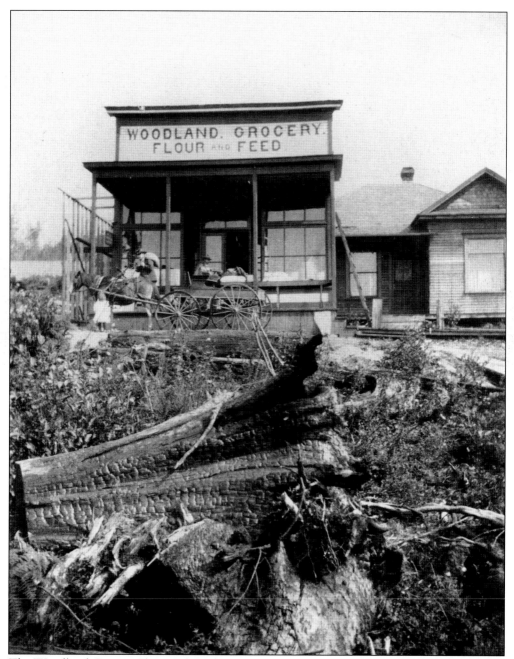

The Woodland Grocery Flour and Feed store was owned and operated by Rasmus Peter Jenson in this 1905 photograph. A carpenter by trade, Jenson also had a store near what is now Sixtieth Street and Fortieth Street NW. (Phinney Neighborhood Association.)

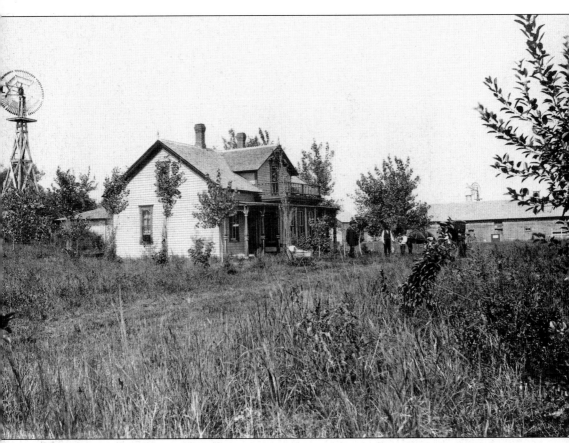

Guy C. Phinney was not alone in beginning to build in the area. This old house was one of the first built on the ridge in 1893. Rasmus Peter Jensen, a carpenter who emigrated from Denmark in 1889, constructed and homesteaded the farm at Northwest Sixtieth Street and Seventh Avenue NW. Jenson also owned a construction business and the Woodland Grocery Flour and Feed, which supplied both dry goods and livestock feed to the rural neighborhood. (Museum of History and Industry.)

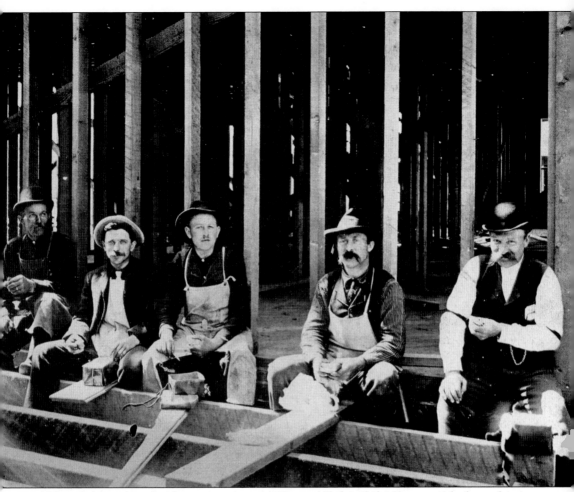

Although he operated at least two stores on Phinney Ridge, Peter Jensen worked mostly as a carpenter, which was his trade. In this photograph, probably taken sometime between 1900 and 1910, Jensen (far right) takes a lunch break with his construction crew at a house. (Museum of History and Industry.)

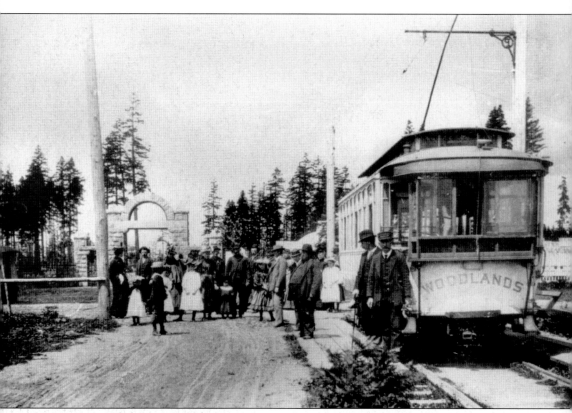

In 1890, the Woodland Park Railway streetcar line began running from Fremont to Guy C. Phinney's residence, subdivision, and a private park called Woodland Park. The area would later be called Phinney's Ridge. Two streetcars started running between Fremont and the park in 1890. The trolley line that ran along the east shore of Green Lake had been extended through Woodland Park. (Museum of History and Industry.)

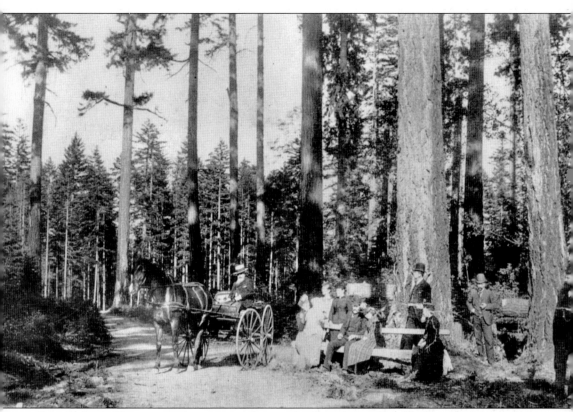

Guy Carleton Phinney can be seen standing at the far right in this old photograph, joined by some friends in Woodland Park in the late 1890s. This is the middle old road to Green Lake from the top level of Woodland Park. (University of Washington special collections.)

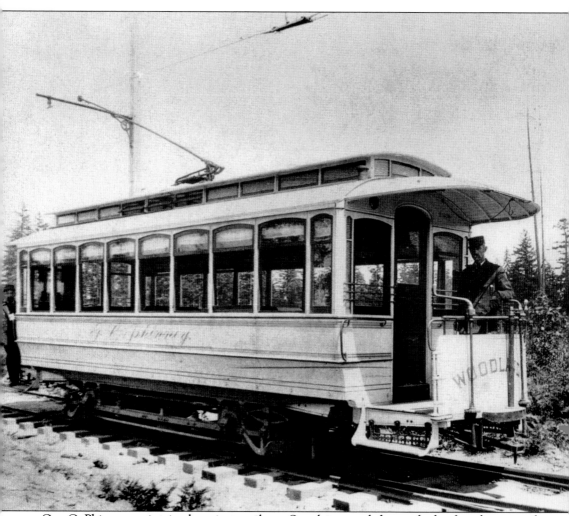

Guy C. Phinney maintained a private rail car. Seattleites used the newly developed system of streetcar lines to make their way out to Woodland Park from Seattle, then still concentrated on the hills around Elliott Bay. Phinney had tracks installed down the hill to the town of Fremont and purchased his own streetcar, which was white and had "Woodlands" painted on the sides. It was popularly referred to as "the White Elephant" because of its color. Phinney hired a driver and used the streetcar to go back and forth to his office downtown. (University of Washington special collections.)

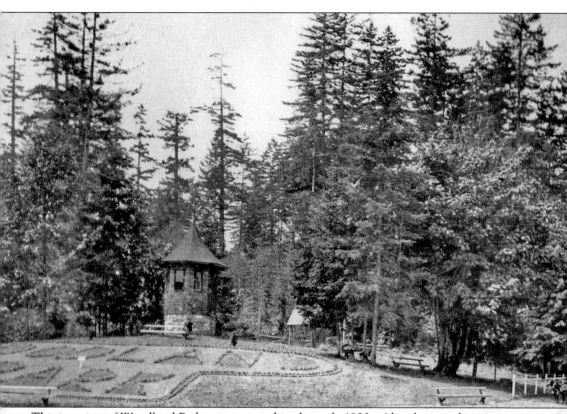

This is a view of Woodland Park as it appeared in the early 1900s. Already it was becoming an increasingly popular destination for visitors. (Phinney Neighborhood Association.)

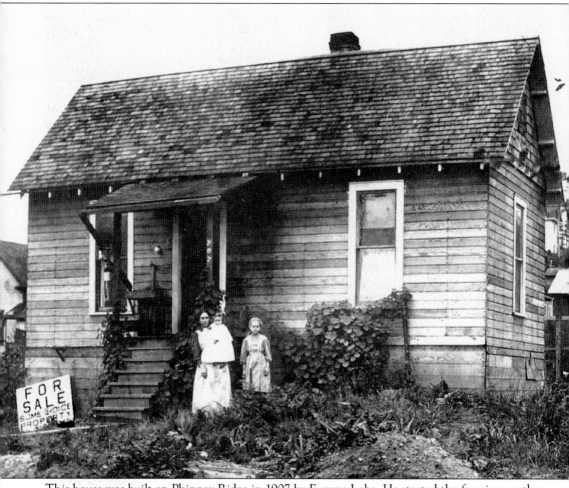

This house was built on Phinney Ridge in 1907 by Eugene Lobe. He started the framing on the house, but the finishing work was done by his brother-in-law, Milo Trumble. The house had only one room but was gradually expanded as money became available. A second floor was added sometime after 1915. There was a water faucet located on the front porch. Dave and Gerry Harris bought the house in 1971, and it is located at 707 North Sixty-fourth Street. They found the original electric permit, dated 1924, in an old fuse box when they redid the wiring. (Phinney Neighborhood Association.)

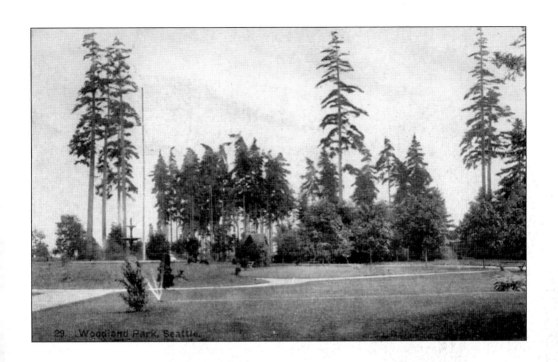

Early Woodland Park was a popular destination for Seattle residents. This postcard, dated August 12, 1912, was sent to a friend in Kentucky and extols the lovely morning after rain the night before saying, "Our lawn looks like this pictorial."

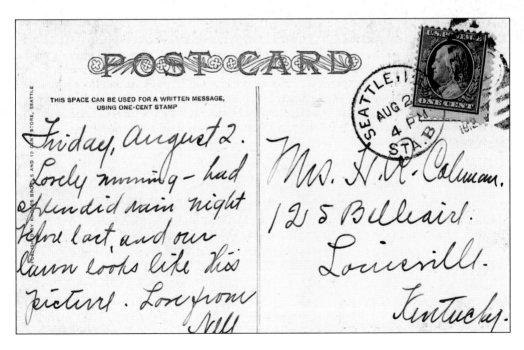

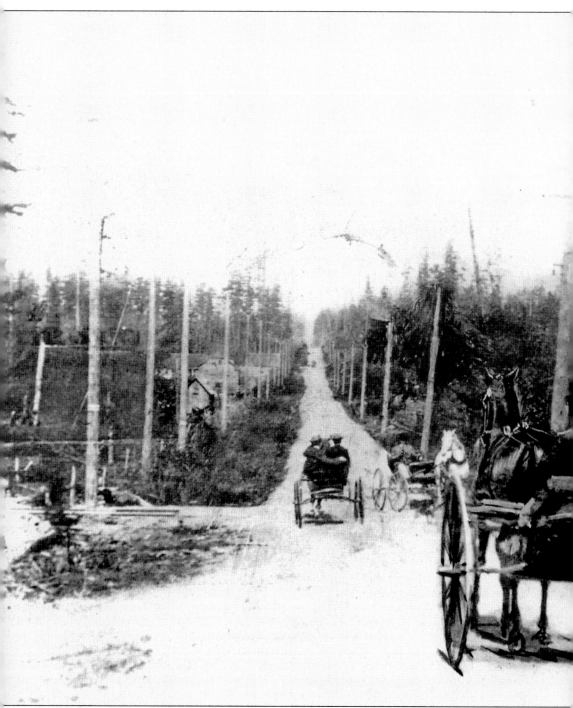

This photograph, taken in the late 1890s, shows Greenwood Avenue looking toward the intersection at Eighty-fifth Street. Thousands lived in the Phinney Ridge neighborhood at this time, but only two groceries, a feed and fuel store, and a real estate office occupied the downtown Greenwood area. This dirt-and-plank road led north past logging camps and the sawmill at Bitter Lake to Edmonds. The Greenwood Cemetery, also known as Woodland Cemetery, was located at Eighty-

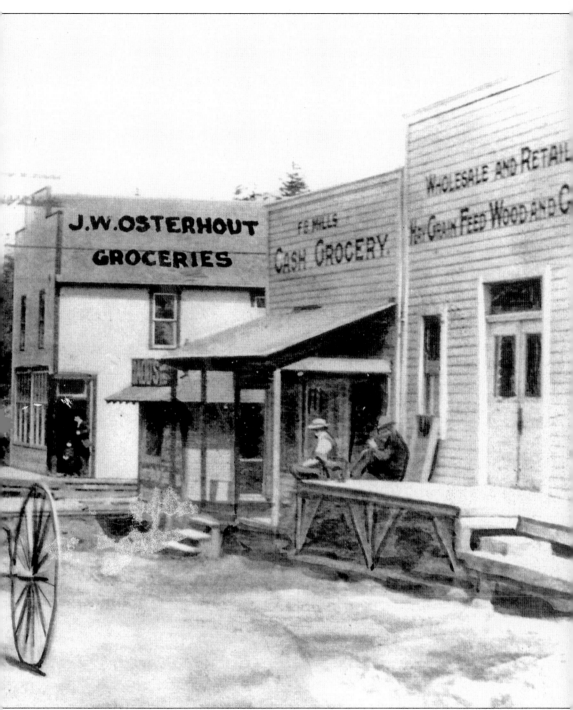

fifth Street and Greenwood Avenue N from 1891 to 1907. The cemetery was removed and the land converted to building lots. It is unknown whether the cemetery was removed for commercial or logistical reasons. The Greenwood Cemetery was designed to be a large cemetery. It was platted as 160 acres. (Phinney Neighborhood Association.)

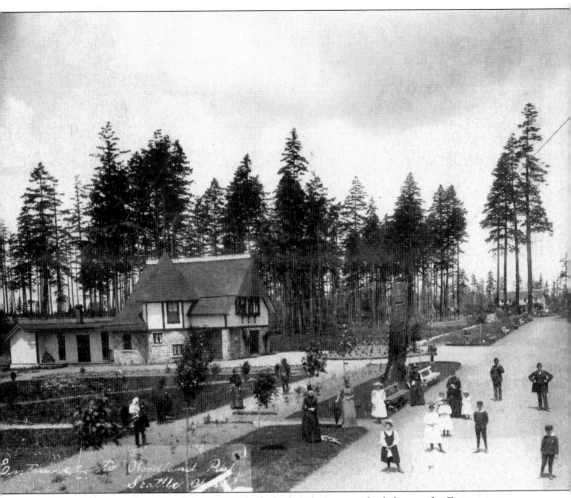

Entrance to Woodland Park
Seattle 91

This is Woodland Park in about 1891. The lodge can be seen at the left near the Fremont entrance. The two small boys on the concrete walk are Arthur and Walter Phinney, sons of Guy C. Phinney, who would die two years later at the young age of 42. This view is looking south toward the hotel, which is visible in the background. (Museum of History and Industry.)

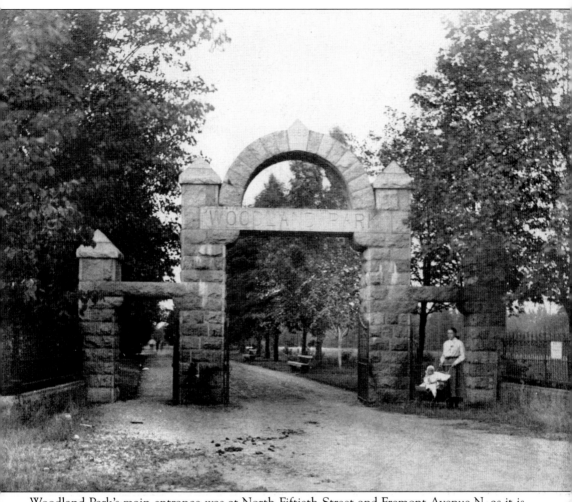

Woodland Park's main entrance was at North Fiftieth Street and Fremont Avenue N, as it is today. At the entrance, there was a stone. Phinney generously opened his estate to the public as long as they obeyed his conspicuously posted rules. He permitted no foul language, firearms, or dogs, which would be "shot on sight." Living things, plants and animals alike, except for dogs, were protected from abuse of any kind. (University of Washington special collections.)

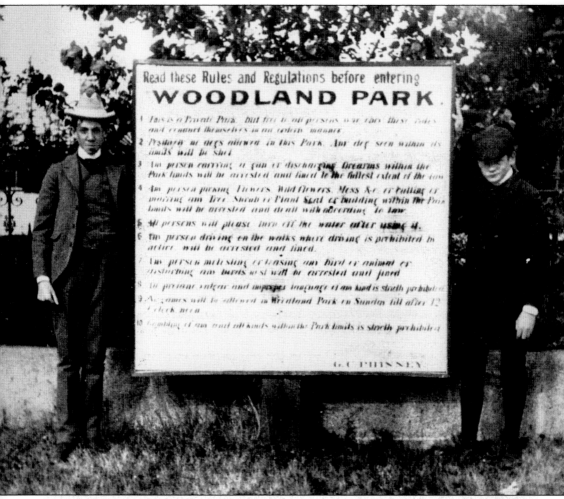

This sign at Woodland Park entrance shows Guy C. Phinney's rules of conduct and reads:
Read these Rules and Regulations before entering
WOODLAND PARK.
1. This is a Private Park, but free to all persons who obey these rules, and conduct themselves in an orderly manner.
2. Positively no dogs allowed in this Park. Any dog seen within its limits will be shot.
3. Any person carrying a gun or discharging firearms within the Park limits will be arrested and fined to the fullest extent of the law.
4. Any person picking Flowers, Wild flowers, Moss & or cutting or marring any Tree, Shrub or Plant and or building within the Park limits will be arrested and dealt with according to law.
5. All persons will please turn off the water after using it.
6. Any person driving on the walks where driving is prohibited by notice will be arrested and fined.
7. Any person molesting or teasing any bird or animal or disturbing any bird's nest will be arrested and fined.
8. All profane, vulgar and improper language of any kind is strictly prohibited.
9. No games will be offered in Woodland Park on Sunday till after 12 O clock noon.
10. Gambling of any and all kinds within the Park limits is strictly prohibited.

G. C. PHINNEY

This house was located at Forty-fifth Street and Woodland Avenue about 1899, when this photograph was taken. It may have been the first house built between Woodland Park and Park Junction. Note the snow in the scene. Seattle had severe winters during this period. (University of Washington special collections.)

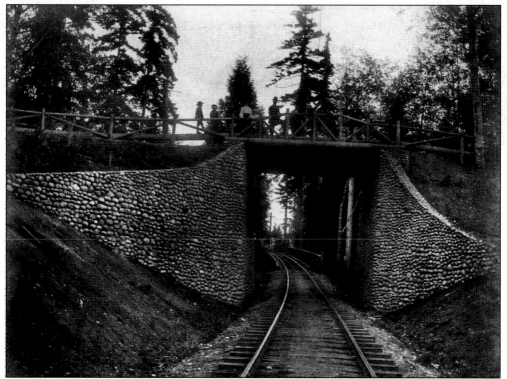

This image is of Woodland Park in the early 1900s and shows train tracks that ran through the park from Phinney Ridge down to Green Lake. Several people can be seen standing on the footbridge. (University of Washington special collections.)

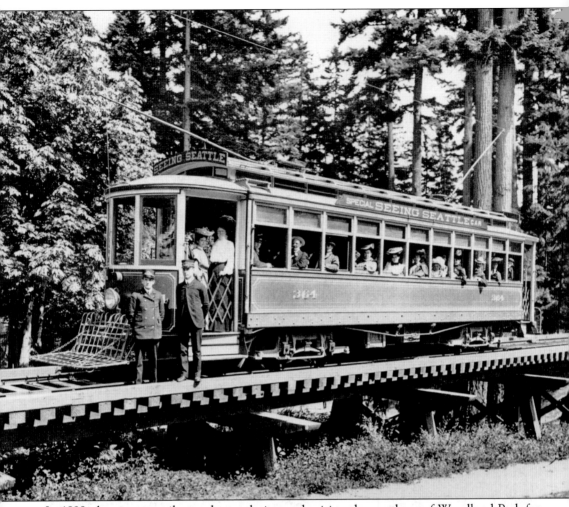

In 1899, the city council passed a resolution authorizing the purchase of Woodland Park for $100,000. The move was controversial, however, due to the feeling of many people that the price was too high and that the park was located too far out of town (at the end of the 19th century, the area around Green Lake was still virtually undeveloped). Seattle's mayor also opposed the acquisition and vetoed the purchase, but the city council overturned the veto, and the papers were signed on December 28, 1899. In 1903, the Seattle Electric Company began regular sightseeing tours on the line during warm weather. In their plan for Woodland Park, the Olmsted Brothers wanted low embankments built beside the tracks to cut down on noise and to screen out the view of the wheels, but this was never done. In this photograph, taken in the early 1900s, a group of sightseers rides through Woodland Park on a special "Seeing Seattle" trolley car sponsored by the Seattle Electric Company. (Museum of History and Industry.)

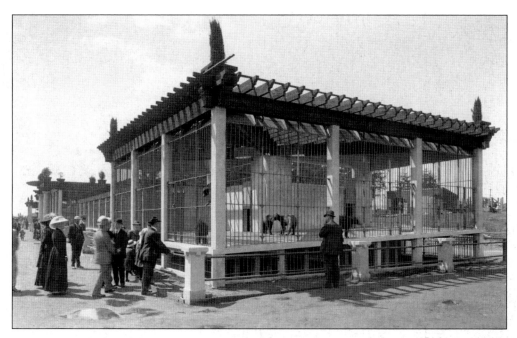

The picture above shows the park after Seattle bought Woodland Park and its small zoo from the Phinney family. Most of the animals were kept in cages with bars and concrete floors. Visitors could go right up to the cages and feed the animals. The tree-lined boulevards that connect one park to another throughout the city were part of the Olmsted design. The Olmsted Brothers, a famous Boston architectural firm that had designed Central Park in New York City, was hired to plan all of Seattle's parks, including the zoo. Today much of their design remains visible in the city's park system. The photograph below shows the Woodland Park bear cage in about 1910. The city had received a gift of two bear cubs that year. (Museum of History and Industry.)

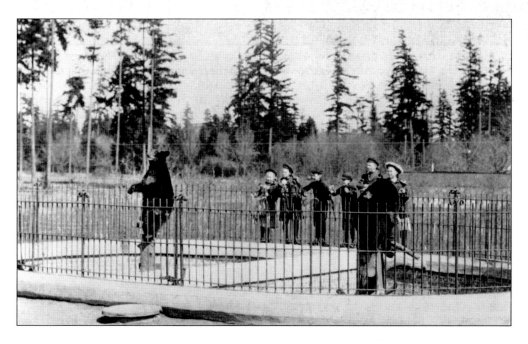

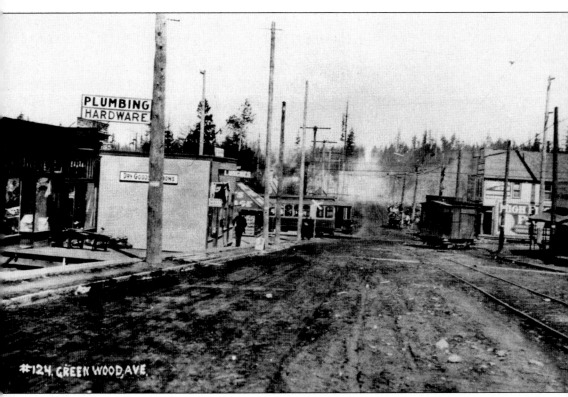

PLUMBING
HARDWARE

DRY GOODS

#124 GREEN WOOD AVE.

This early view shows the intersection of Eighty-fifth Street and Greenwood Avenue about 1910. Before the interurban was built, Phinney streetcars only came south as far as Seventy-fifth Street. Fred Sander had launched construction of an interurban railway between Seattle and Everett in 1900, but it took him six years to complete six miles of track between Ballard and Hall's Lake. The regional subsidiary of the giant Stone and Webster utility cartel purchased Sander's line in 1909 and organized the Seattle-Everett Traction Company to operate it. Stone and Webster already managed the Seattle-Tacoma interurban service. In a sign of changing attitudes, Highway 99's new Aurora Bridge opened in 1932 without provision for interurban rails. Anticipating Seattle's removal of local streetcar tracks, the company finally abandoned the Seattle-Everett railway on February 20, 1939. (Phinney Neighborhood Association.)

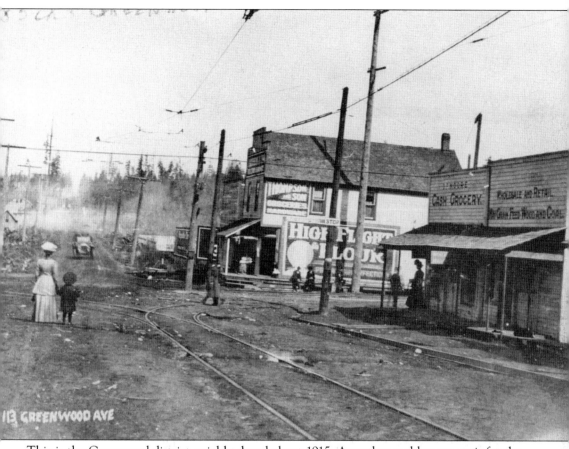

This is the Greenwood district neighborhood about 1915. A mother and her son wait for the interurban streetcar at North Eighty-fifth Street and Greenwood Avenue N in 1910. At that time, interurban service linked the farthest northern reaches of the city with Ballard and other streetcar lines to the south. North Eighty-fifth Street served as the longtime northern city limit until annexations took place. (Phinney Neighborhood Association.)

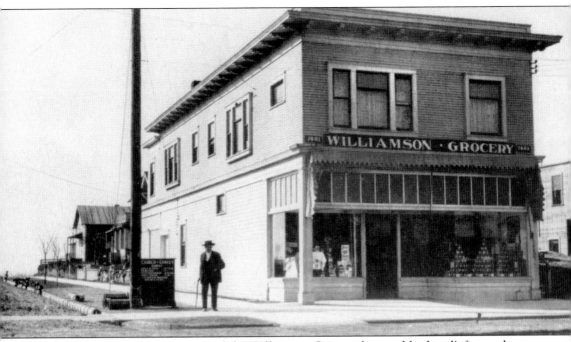

In 1910, Oscar Williamson opened the Williamson Grocery, his neighborhood's first such store, at 7401 Greenwood Avenue. He delivered groceries to his customers in a horse-and-buggy until he purchased his first car in 1915. Coal oil, used for kerosene lamps, was the store's biggest seller at the time. Oscar's wife, Minnie, was a painter, and the grocery featured her art (including hand-painted china) in its front window. The business became so successful that in 1916, the couple moved two doors down into a larger space they called the Williamson Mercantile Company. They continued to run the grocery at a third location on the same block until they retired in the late 1940s. The building at 7401 became a pharmacy, and after the Williamsons moved in 1950, it became Greene's 74th Street Tavern. It currently houses the 74th Street Ale House. (Museum of History and Industry.)

Two

Making a Home

Shortly after the beginning of the 19th century, along with the construction of bungalows and box houses, families came seeking fresh air and elbow room that was increasingly difficult to find in a Seattle that had become a boomtown in the wake of the Klondike gold rush of 1897. The presence of families meant schoolchildren.

During this period, the Greenwood area remained mostly marshy swamp, lakes, and woods cut by trails, with a dirt-and-plank road cutting through that connected Seattle with Edmonds and the hinterlands to the north. People often took their horse-and-buggy and rode to Edmonds to eat and then came back. They called that a pleasant day's outing.

The Greenwood neighborhood, with its boggy beginnings and delayed drainage systems, could not compete with nearby Green Lake, Phinney Ridge, or Ballard for their wealth of housing stock, well-maintained parks, or natural beauty. Nonetheless, a walk along its side streets, still without sidewalks, is a reminder of what was once country living beyond the North Eighty-fifth Street limit.

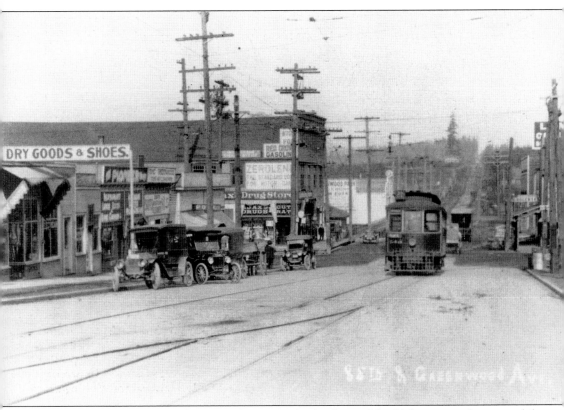

This view is of Greenwood Avenue about 1921. At the dawn of the 20th century, the automobile and all its subspecies were still a novelty. Rarer still were decent roads. Mud farm tracks were the norm, and paved roads (brick at first) would come slowly. Regular stream-driven railroads, of course, ran between most cities, but passenger service, competing for track space with freight trains, was not frequent enough to satisfy the growing demands of the new suburban commuters. In the central Puget Sound region of Washington, the geography of railroad routes hugged the coast north of Seattle, bypassing the growing hinterlands and filling the passenger service gap. Waterborne travel via privately owned mosquito fleets serviced coastal communities but did not offer convenient travel options to the multitude of people moving out to the subdivided, cutover timberlands of the inland suburbs. (Phinney Neighborhood Association.)

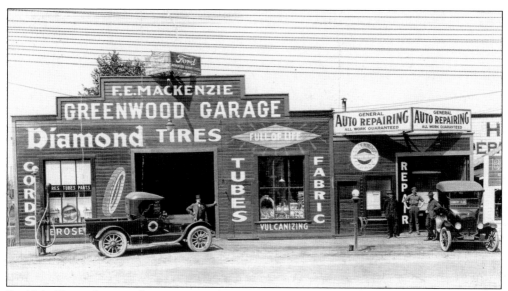

Fred MacKenzie began selling automobile parts at his Greenwood sign-and-paint store in 1918, and two years later, he opened this garage at 8531 Greenwood Avenue. The first automobile arrived in the neighborhood in 1906, but Greenwood and Phinney Avenues proved too rough and muddy for cars. The city installed a plank road in 1909. Three years later, at the urging of the Phinney Improvement Club, the city paved Phinney and Greenwood Avenues to Eighty-fifth Street. While there were only about two dozen automobile supply and repair shops in Seattle in 1910, MacKenzie's was one of more than 400 in the city by 1920. (University of Washington special collections.)

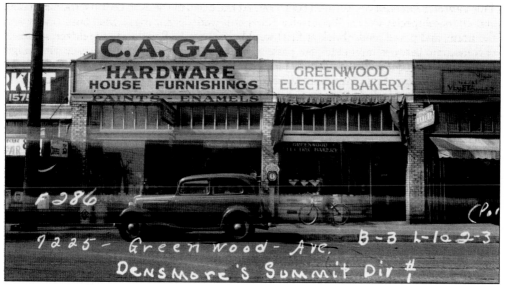

C. A. Gay Hardware and the Greenwood Electric Bakery, located at 7227 Greenwood Avenue in the 1930s, is the present location of the Greenwood Bakery. Despite the Great Depression, most stores in the Greenwood-Phinney neighborhood did well during the 1930s. The shop first opened in 1928, and there has been a bakery at this location ever since. The neighborhood's oldest businesses, including Greenwood Hardware and Ken's Market, also currently inhabit this block. (Phinney Neighborhood Association.)

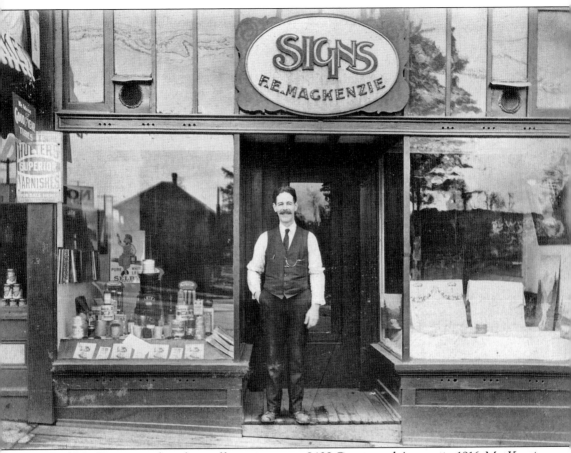

Fred MacKenzie stands in front of his sign store at 8408 Greenwood Avenue in 1916. MacKenzie came to Seattle from Minnesota in 1908 and worked as a laborer before becoming a sign maker in 1912. He joined a growing number of business owners who opened stores and services near the intersection of Eighty-fifth Street and Greenwood Avenue after trolley line no. 21 was extended to Seattle's city limits in 1909. The intersection had been a marsh in the early 20th century, but it became a commercial center that served the rapidly growing neighborhood by the 1920s. In 1918, MacKenzie began catering to the growing number of automobile owners in Greenwood by selling automobile parts at his store. He operated his shop at this location until the early 1920s, when brick and stone storefronts began to replace Greenwood Avenue's early wooden buildings. (University of Washington special collections.)

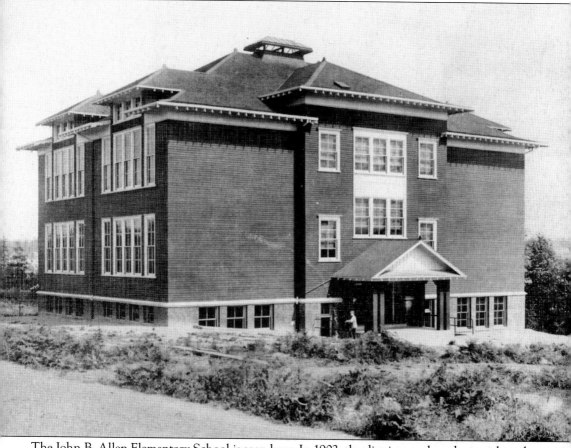

The John B. Allen Elementary School is seen here. In 1902, the district purchased an unplotted three-acre tract along the east side of Phinney Avenue at Sixty-sixth Street. The school was named Park School for its location just north of Woodland Park, which the city purchased in 1899. A deep depression on the property was filled, but it still dramatically sloped 50 feet from west to east. Although Park was an all-portable school, it opened as an independent facility rather than as an annex. From the beginning, it was squeezed for space. During the first year, 1902–1903, three portables housed 99 students in grades first through seventh. In March 1903, the school's name was changed to Kent, but in September of the same year, the school board changed it back to Park. The following school year, a fourth portable was added, and enrollment rose to 171 in grades first through eighth. Reacting to the climbing enrollment, the school board decided in November 1903 "that as soon as plans are proposed and approved to erect . . . an eight-room building [will be constructed] at the Park School" site. (Phinney Neighborhood Association.)

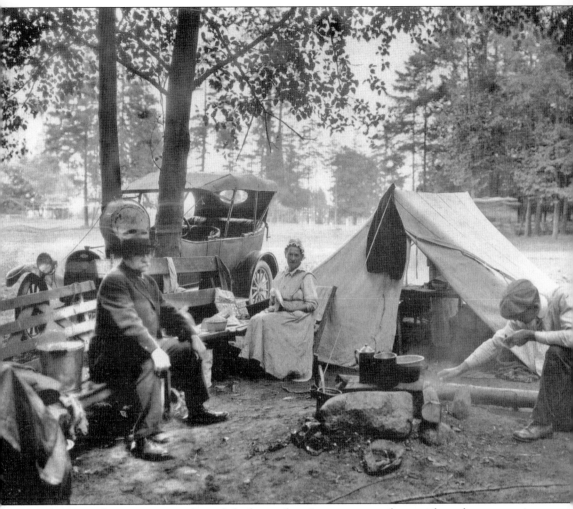

As cars got less expensive and people had more free time, many people started to take car camping vacations. They camped in farm yards, by the roadside, or in city parks. Cities and towns soon started building organized campgrounds. In 1920, Seattle's parks department opened an automobile tourist camp in the northern part of Woodland Park, overlooking Green Lake. This photograph shows people camping at Woodland Park sometime between 1918 and 1920. Their tent is set up and ready, and their meal is cooking on the fire. (Museum of History and Industry.)

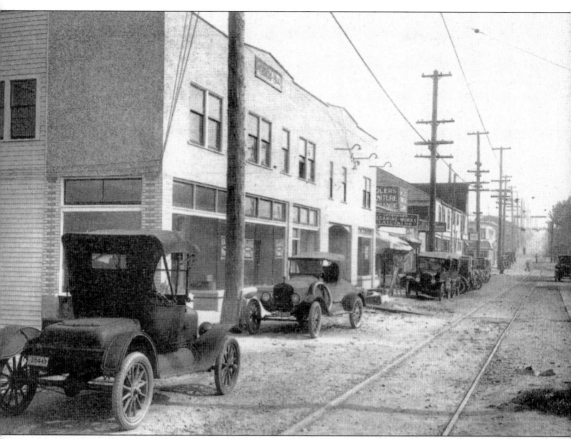

This is a scene looking east on Eighty-fifth Street toward Greenwood Avenue about 1925. There was already a furniture store and cleaners here, and other local businesses were rapidly starting up. (Museum of History and Industry.)

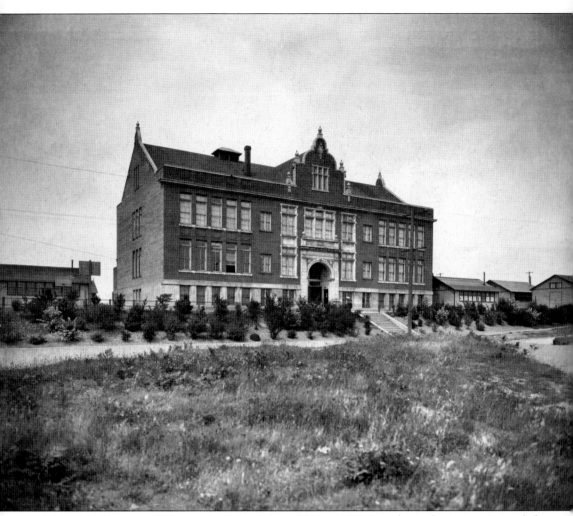

This is the Greenwood Elementary School about 1910. In 1891, Seattle city limits were extended past Green Lake to North Eighty-fifth Street. By the early 1900s, the Greenwood neighborhood consisted of two or three stores and a few scattered houses surrounded by a marshy wetland. From the lumber camps to the north and west, logs were floated into Greenwood to be hauled to Green Lake on their way to sawmills. The Seattle School District owned property west of Third Avenue, but this land was judged too swampy for construction and sold. Pioneer David T. Denny owned a 40-acre tract of land west of Greenwood Avenue between Eightieth and Eighty-fifth Streets. This property was laid out as a cemetery, as it included an old American Indian cemetery, but that use was never fully developed. In January 1909, the Seattle School District purchased a portion of this land for a new school. Construction of a Jacobean-style school began in 1909 with a design identical to the Emerson and Hawthorne schools, which were also being constructed at that time. James Stephen, the district architect, declared this brick design more sanitary, better equipped, and more convenient than earlier wood-frame buildings. The Greenwood School opened with 77 students in grades first through seventh. Regrading of the streets in 1914–1915 left the building and grounds considerably higher than the roadways, necessitating the construction of retaining walls on three sides of the grounds. (Greenwood Elementary School.)

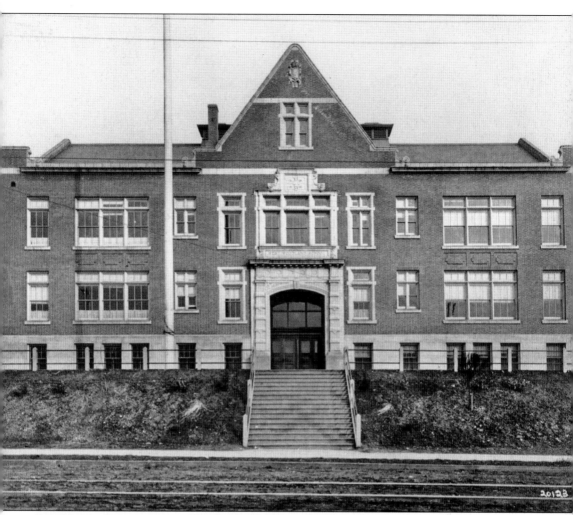

Seattle's population grew quickly after 1900. When the West Woodland School opened in 1910 on Fifth Avenue NW, it was already overcrowded. Wings were added to the building in 1913 and 1925. The school continued to serve the Phinney Ridge area until the late 1980s, when it was replaced by a new building. This photograph, taken in 1928, shows the West Woodland School with its two additions. The original school building can be seen between the two wings. Before the first addition could be completed in 1913, students were asked to voluntarily transfer to other nearby schools. Additions in 1913 and 1925 created a total of 25 classrooms. At 40 students per class, the district considered the capacity to be 1,000 students. By 1930, West Woodland was the largest elementary school in Seattle. (Museum of History and Industry.)

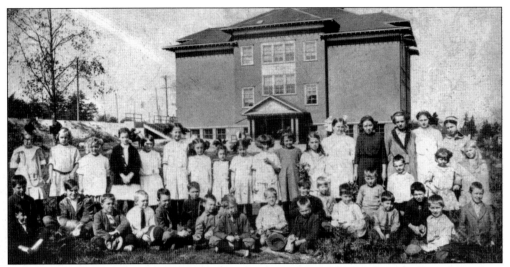

Students pose in front of the eight-room John B. Allen Elementary School in 1918. In 1900, there was no school in the growing Greenwood-Phinney neighborhood, and many students were taught in private homes. The city purchased the three-acre parcel in 1902 for $1,850, and children first attended classes in a group of portables called Park School, named for Woodland Park. The two-story, eight-room building was completed in 1904, and 278 students crammed into the structure in its first year. (Phinney Neighborhood Association.)

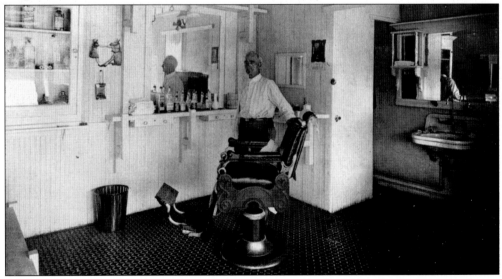

Adolph Hahn stands in his barbershop on Phinney Avenue in the 1920s. The German immigrant opened the shop in 1923 after working as an insurance salesman, farmer, artist, and a clock repairman. Though his shop changed locations twice, he operated his business for over 20 years near the intersection of Sixty-fifth Street and Phinney Avenue. Neighborhood residents could shop at a variety of stores at this intersection during this time; businesses included a butcher, a grocery, a cleaners, a dry goods store, a variety store, a shoe repair shop, and a store that sold coffee, tea, milk, butter, and eggs. (Phinney Neighborhood Association.)

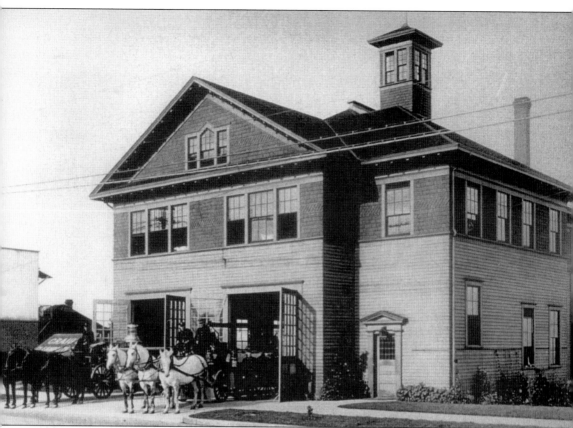

The Greenwood Fire Station at 7304 Greenwood Avenue N is seen here as it appeared about 1916. Greenwood firefighters relied upon these horse-drawn wagons until 1922. Their stall doors opened automatically with the fire alarm, and the horses were trained to rush into place in front of the fire wagons. Harnesses hung from pulleys on the ceiling, enabling the firefighters to quickly hitch the horses to the wagons. The fire department replaced the structure in 1950, needing a more efficient building—one that did not require firefighters to slide down brass poles but blended in with the architecture of the neighborhood. (Museum of History and Industry.)

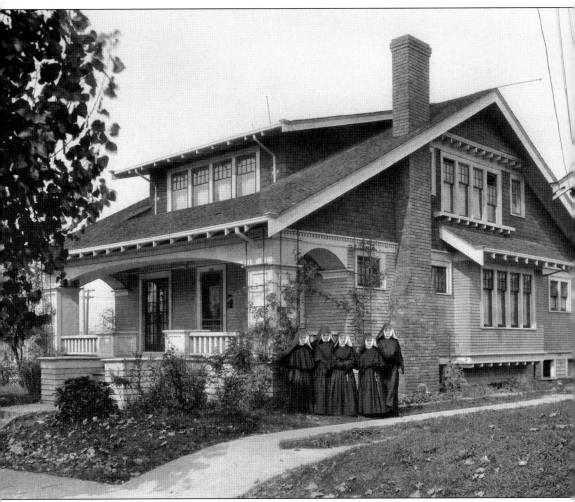

In 1923, five Catholic Sisters of Charity of the Blessed Virgin Mary moved to Seattle from Dubuque, Iowa, to begin teaching at the new St. John's School. The B.V.M. Sisters were very active in the life of the Greenwood parish. In addition to teaching school and Sunday school, they led choirs and clubs, served on the parish council, and were part of social justice committees. This photograph, taken around 1926, shows five Sisters of Charity next to their bungalow on Northwest Seventy-ninth Street in Greenwood. This house, which looked like others in the neighborhood, served as their convent from 1926 to 1948. (Museum of History and Industry.)

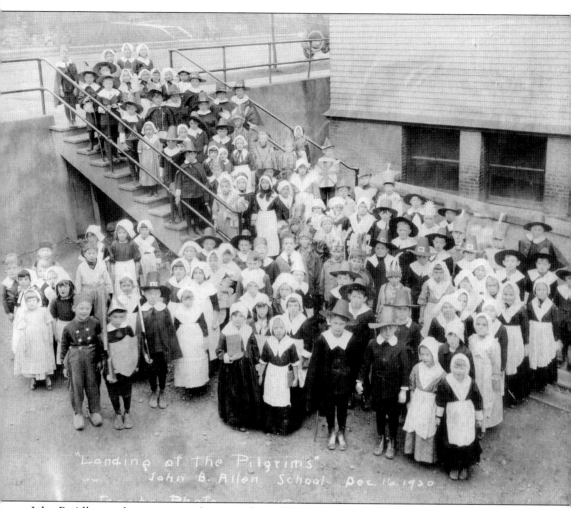

"Landing of The Pilgrims"
John B. Allen School Dec. 16. 1920

John B. Allen students pose as pilgrims in front of the eight-room school about 1920. Enrollment reached 699 students in the 1920s, after which time a second brick building was completed adjacent to the original. Phinney Avenue was widened in 1911, and city engineers built a retaining wall along the structure's west side, giving the impression that the school had sunk. The building currently serves as the Phinney Neighborhood Center. (Phinney Neighborhood Association.)

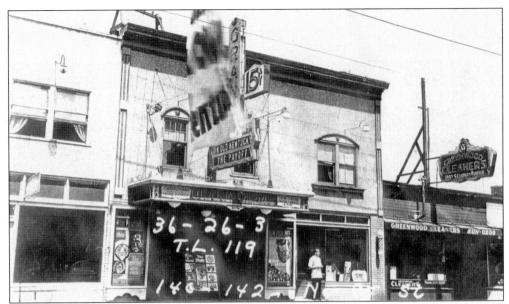

Located in Seattle's Greenwood neighborhood, the Grand Theatre building still exists. *In Old Kentucky* and *The Payoff* were playing at the Grand Theatre in March 1936. Greenwood has long had a theater on North Eighty-fifth Street. But it wasn't always worth the price of admission. Where the Taproot Theatre now stages everything from musicals to murder mysteries in a lovely and intimate setting, there used to be martial-arts films and porno flicks. Taproot, which used to lease space in churches and schools, bought the building in 1988 but did not start producing there until 1996. It took that long for a devoted corps of volunteers, occasionally assisted by contractors, to renovate the space. The roof leaked, so whenever it rained, patrons played musical chairs, trying to find a dry spot. They alternated among couches, airline seats, folding chairs, whatever there was. Only a dozen or so of the seats matched. (Gordito's.)

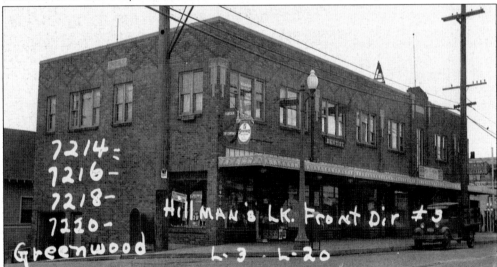

Most commercial development along Phinney and Greenwood Avenues occurred in the 1920s and early 1930s. This two-story brick structure at Seventy-third Street and Greenwood Avenue, built in 1931, is typical, and looks much the same today as it did back then. (Phinney Neighborhood Association.)

On May 16, 1928, the Greenwood-Phinney Branch of the Seattle Public Library opened at 7020 Greenwood Avenue N. Funds to rent the storefront were raised by neighborhood groups. The branch proved to be very popular and was expanded twice before 1954, when a new Greenwood Branch opened. The branch became a center of community activity, particularly for high school students who had few recreational options after school. In the evenings, overcrowding and noise demanded much of the staff's time. By 1930, patrons began to complain that they had read what they wanted in the small collection, and they wanted more. (Greenwood Public Library.)

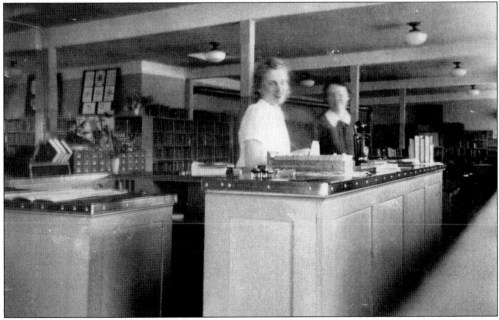

This is the front desk of the 1928 Greenwood-Phinney Library. The branch became a center of community activity, particularly for high school students who had few recreational options after school. Some came to the branch to study, but many used it for loafing and loitering. In early 1932, the branch was remodeled to almost double the space. This came just before drastic budget cuts during the Great Depression. To save money, the branch closed one day a week, and staff hours and salaries were slashed. (Greenwood Public Library.)

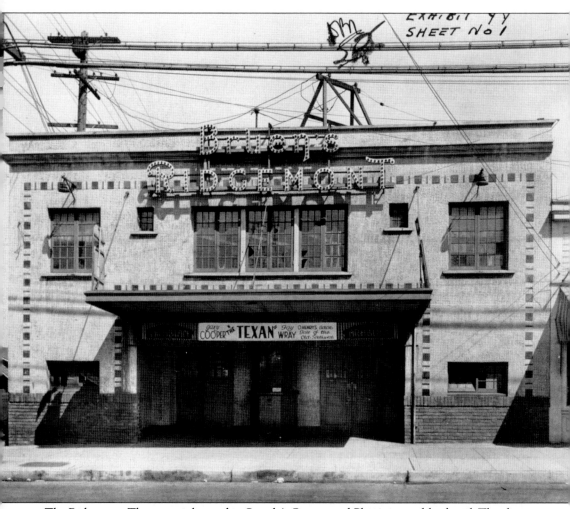

The Ridgemont Theatre was located in Seattle's Greenwood-Phinney neighborhood. The theater originally had a 2/6 Kimball theatre organ (opus No. 6842) installed in 1923. A. H. Biggs was the organist at the Ridgemont in 1927. Popular Northwest organist Ed Zollman played at the Ridgemont for several years. In the 1960s, it began showing foreign films and continued as an art-house theater. After closing in 1989, it was demolished in October 2001 and replaced by the Ridgemont Condominiums. (University of Washington special collections.)

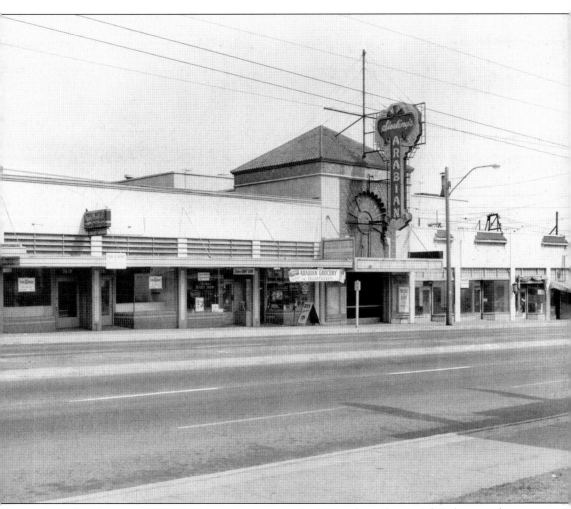

The Arabian Theatre was at 7610 Aurora Avenue in the 1930s, about the time this photograph was taken. The Arabian Theatre building still exists and is now home to the "I AM" church. Note that at the time of this photograph, the Arabian is playing the movie *The Texan* starring Gary Cooper. The theater closed as a movie house in 1956. (University of Washington special collections.)

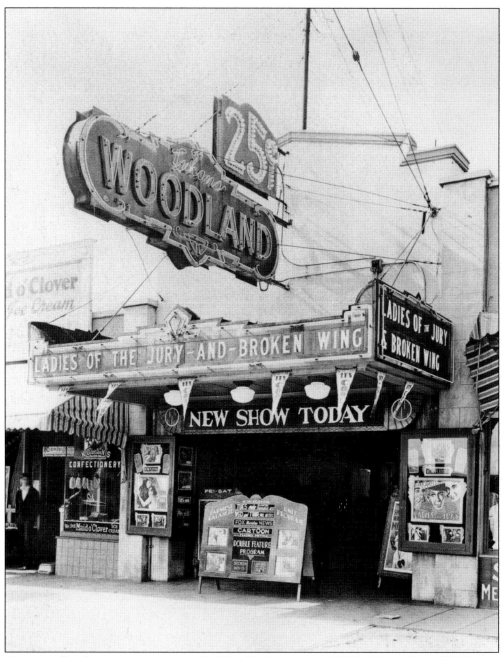

Greenwood's other movie theater was the Woodland, located at 610 Northwest Sixty-fifth Street. It was a part of the Sterling Recreation chain. The author has fond memories of spending many a Saturday afternoon matinee there in the mid-1940s when there was always a cartoon and a serial chapter, like "Zorro's Black Whip," playing. Often the theater was so crowded that some kids sat in the aisle. This photograph was taken in the 1930s. (University of Washington special collections.)

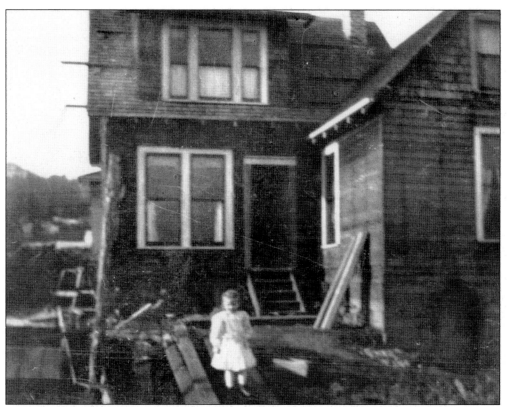

A little girl stands outside in the backyard of what may have been her home in the Greenwood area is the late 1920s or early 1930s. As the population was growing, so was the need for more educational facilities. (Phinney Neighborhood Association.)

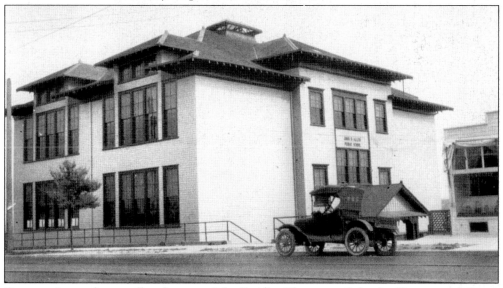

Construction work was well under way at John B. Allen Elementary School at Sixty-seventh Street and Phinney Avenue to expand the facility. This photograph shows the school in December 1934. (Phinney Neighborhood Association.)

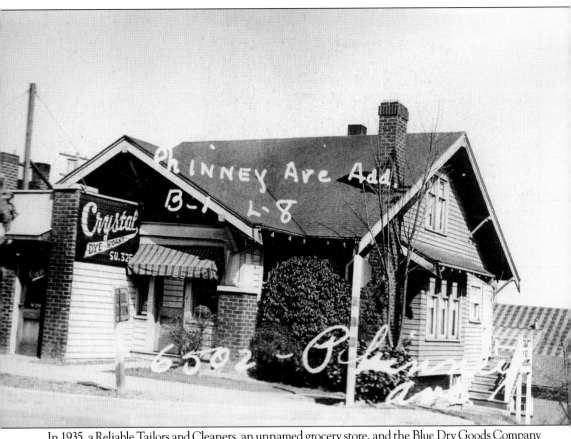

In 1935, a Reliable Tailors and Cleaners, an unnamed grocery store, and the Blue Dry Goods Company were all located in the 6200 block of Phinney Avenue. (Phinney Neighborhood Association.)

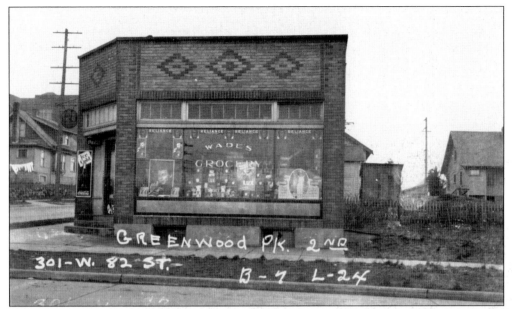

This market was located at the corner of Eighty-second Street and Third Avenue near Greenwood School. Built in 1909, it was originally a one-story, two-room, mom-and pop grocery store frequented in the 1940s and 1950s by students for its candy. In 1967, it became Mama Angeline's Spaghetti Sauce Factory. Later the building became the home of Gala Costumes and stuck with that incarnation until it was purchased as a home in 1995. (Phinney Neighborhood Association.)

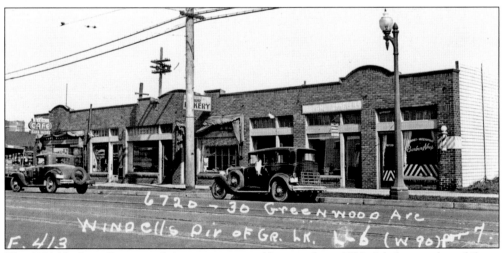

The 6900 block on Greenwood Avenue is pictured here in about 1934. A bakery and a café have opened, showing how the area continued to thrive. (Phinney Neighborhood Association.)

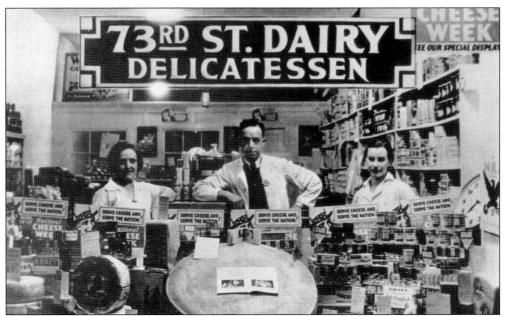

John and Greta Petersen opened the 73rd St. Dairy at 7216 Greenwood Avenue in 1931. They added a delicatessen after Greta and her two children learned how to make meat products, such as lamb sausage, liver pate, and fish balls, during a visit to Denmark in 1934. The business became especially popular during World War II when butter was scarce. The Petersens had a source in North Dakota, and the line for butter frequently stretched out the door. National Cheese Week was a Kraft promotion that appealed to Americans' patriotism, as it encouraged them to consume their way out of the Great Depression by purchasing American dairy products. The Petersens sold the business in 1946 when large supermarkets increasingly drew shoppers away from small, neighborhood stores. This is now Santoro's Bookstore. (Museum of History and Industry.)

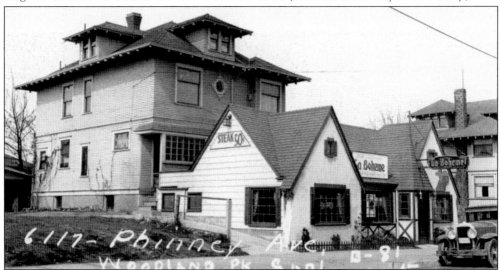

The La Boheme Tavern, located at 6117 Phinney Avenue near Woodland Park, was where a steak cost 50¢ in the 1930s. It looks much the same today, although an outside patio has been added. It is now Sully's Snowgoose Saloon, and the price of a steak is more. The house behind it is now an apartment house. (Phinney Neighborhood Association.)

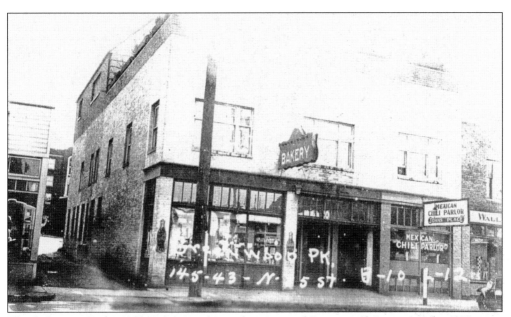

This bakery on Eighty-fifth Street was located just west of Greenwood Avenue in the 1930s next to the Mexican Chilli Parlor. It is now the home of Gordito's restaurant. (Gordito's.)

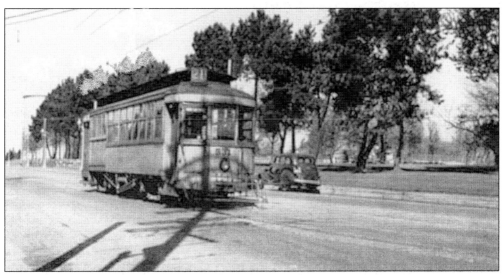

This trolley coming from Ballard approaches Woodland Park bringing visitors to the increasingly popular destination. (Phinney Neighborhood Association.)

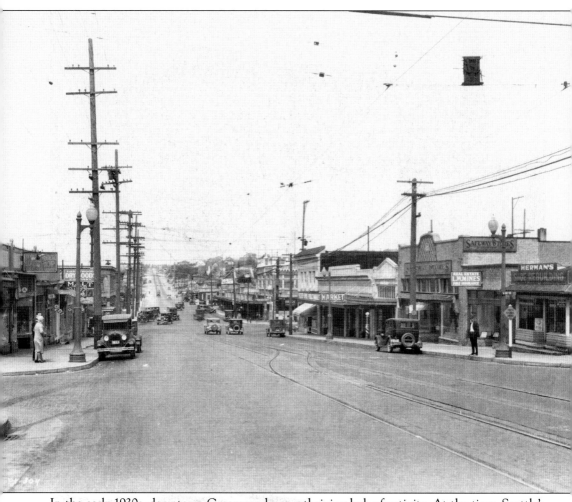

In the early 1930s, downtown Greenwood was a thriving hub of activity. At the time, Seattle's northern city limits were at Eighty-fifth Street in the Greenwood neighborhood. People could take the streetcar to Greenwood and catch the interurban railway north to Everett and other outlying towns. This photograph shows what the Greenwood business district looked like around 1932 and looks north across the intersection of Greenwood Avenue and Eighty-fifth Street. (Phinney Neighborhood Association.)

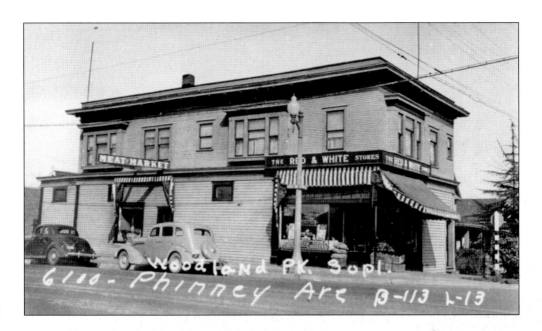

In the 1930s, the Red and White Store was located at 6111 Phinney Avenue, next to a meat market, which might have been part of the store. The photograph below illustrates what the street looks like today. (Phinney Neighborhood Association.)

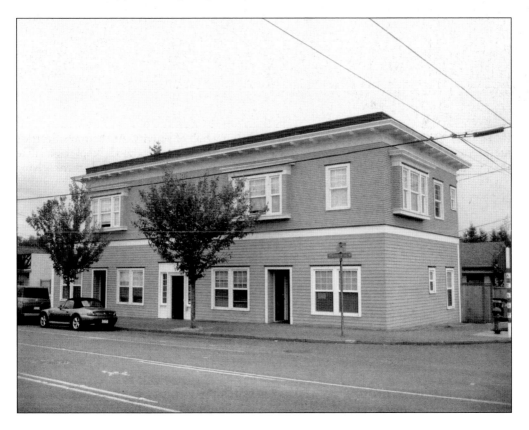

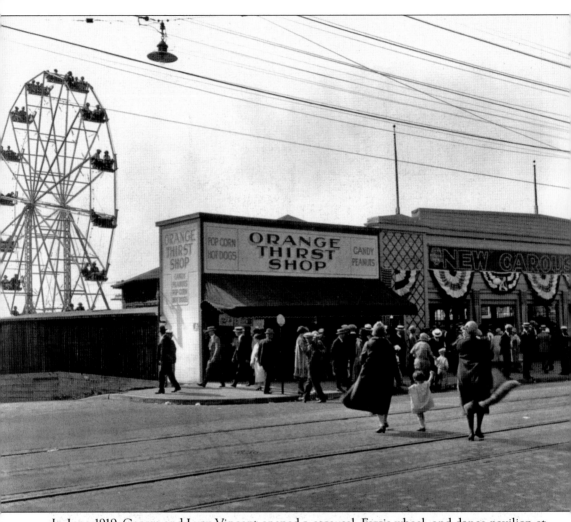

In June 1919, George and Lucy Vincent opened a carousel, Ferris wheel, and dance pavilion at 5501 Phinney Avenue directly across the street from Seattle's Woodland Park Zoo. Despite initial protests by neighbors and the Seattle Board of Park Commissioners, who objected to having the dance pavilion so close to Woodland Park, the Vincent's operated the business through 1934, when it is destroyed by fire. This photograph, taken on a sunny, windy afternoon around 1925, shows crowds visiting the Vincent Ferris wheel, merry-go-round, and snack stand. The business operated under the names Woodland Park Pavilion and Woodland Amusement Park. The concession stand was called the Orange Thirst Shop. On the evening of August 26, 1934, the carousel and its pipe organ, Ferris wheel, skating rink, and concession stand were destroyed in a three-alarm fire. The fire drew thousands of curious spectators, many of them attracted by the horrific sight of the enormous Ferris wheel ablaze. The *Seattle Post-Intelligencer* reported, "Screaming animals in the Woodland Park Zoo added a weird accompaniment to the crackling of the flames, and many persons on their way to the scene imagined the fire was in the zoo buildings across from the recreation center. The fire destroyed interior of Woodland Amusement Park concession stand at Fifty-fifth Street and Phinney Avenue, Seattle, March 12, 1935. (Museum of History and Industry.)

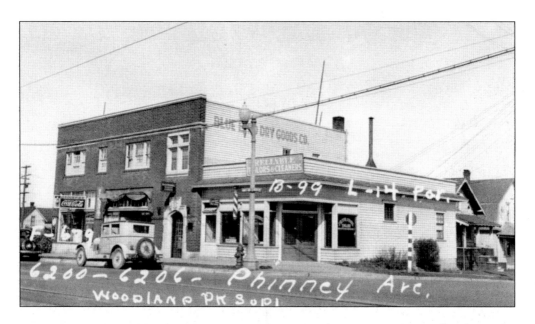

This home at 6502 Phinney Avenue looks like it might have been some kind of home business in 1935. There was a cleaner next door. This block was close to the John B. Allen Elementary School. Notice the school's caution sign at the corner. Below is the same location today. (Phinney Neighborhood Association.)

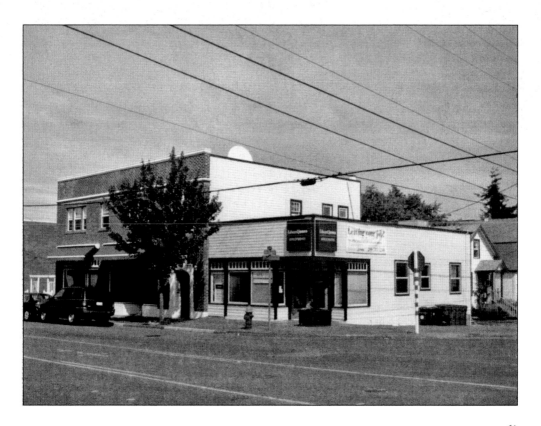

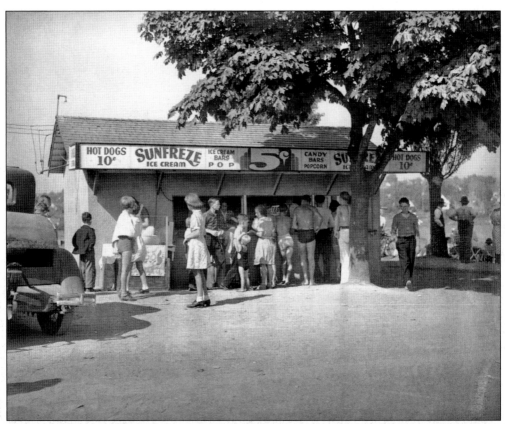

This popular concession stand at Woodland Park was operated by Dave or Joe Himeloch. A photographer from Seattle's *Post-Intelligencer* took this photograph in August 1938. (Museum of History and Industry.)

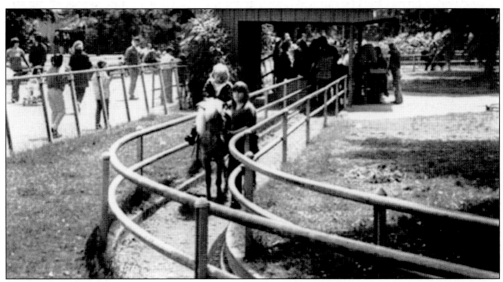

The Woodland Park pony rides were popular with kids in the 1930s and into the 1960s. Volunteers would lead the ponies for younger kids to ride. (Woodland Park archives.)

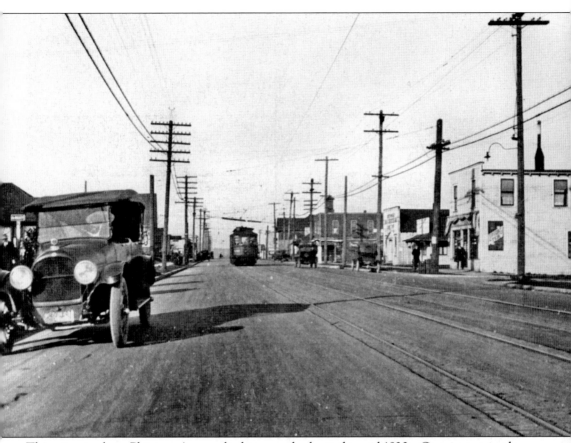

This view is along Phinney Avenue looking south about the mid-1930s. Growing up in the 1920s and 1930s, Walter Van Ottingham lived on Seventy-second Street near Third Avenue. At that time, a private bus line traveled from Eighty-fifth Street down Third Avenue all the way to downtown. Walter's next-door neighbor owned the bus line, and his son would ride the bus three blocks, from Seventy-second to Seventy-fifth Streets, because he could ride for free. Walter remembers going with his brothers and sisters to catch pollywogs in the ponds in the area that is now Fred Meyer and Bartell Drugs. He attended Greenwood Elementary, followed by Ballard High School. He served in the army and was stationed in the Pacific during World War II. Walter and his wife, who was originally from Minnesota, raised four daughters in the neighborhood, and all four of them remained in the Seattle area. (Phinney Neighborhood Association.)

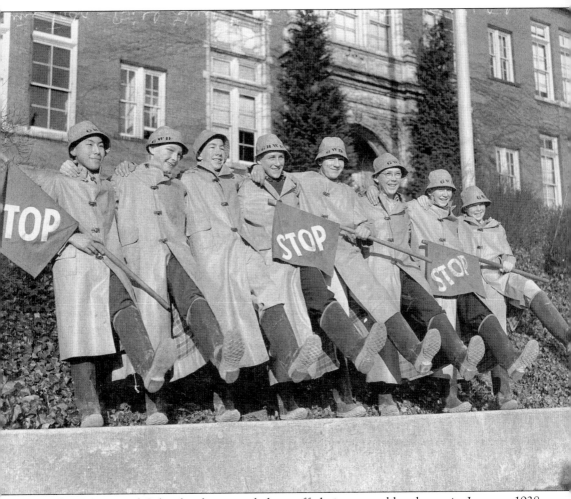

The Greenwood School safety patrol show off their new rubber boots in January 1938. Grover K. Matsuda, owner of the Greenwood Cleaners and Dyers on Eighty-fifth Street, donated the boots to the school to show his appreciation for the high-quality education that his grandsons were receiving in Seattle's public schools. Before his donation, school patrol members frequently lost an hour of school while they dried their shoes and socks during wet weather. Four years after the picture was taken, Matsuda no longer operated his business, and his grandsons, like other Japanese-American students (including Tatsumi Tada, shown on the left) no longer attended Seattle schools. Instead they were interned along with their families at Minidoka Relocation Center, Idaho, for the duration of World War II. (Museum of History and Industry.)

Three

CREATING A COMMUNITY

The commercial district of Phinney and Greenwood paralleled the tracks on both sides of the right-of-way. By the 1930s, the business district of Greenwood was well established, and many of the brick and mortar buildings of the period remain in use today just beyond the Phinney neighborhood's northern reach.

In the 1940s, the Greenwood Commercial Club boosters had created a "Miracle Mile" along Greenwood Avenue from Eighty-fifth Street on the north to Sixty-seventh Street on the south with businesses that made the neighborhood self-sustaining: bakeries, appliance shops, shoe repair stores, taverns, restaurants, grocery stores, hardware stores, druggists, supermarkets, doctors, dentists, barbers, variety stores, and a branch of the Seattle Public Library. Even a MacDougall and Southwick department store opened a branch store on the main intersection of the neighborhood at North Eighty-fifth Street and Greenwood Avenue.

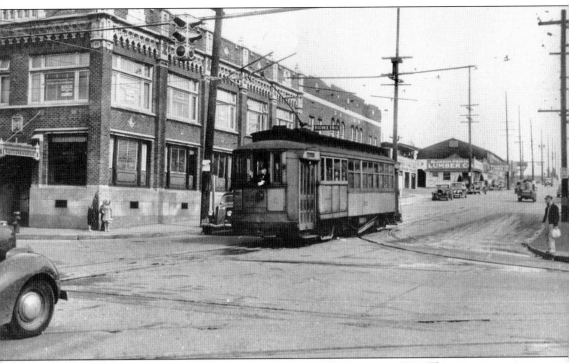

This is Eighty-fifth Street looking east from Greenwood Avenue in 1941. This intersection was a commercial center that marked the north end of Greenwood's Miracle Mile. Stores included a department store, two groceries, two taverns, an ice cream parlor, a pet and garden store, a Texaco gas station, a Bartell Drugs, a bowling alley, a doctor's office, a jeweler, a custom glove maker, a number of restaurants, and a branch of Seattle First National Bank. Shoppers frequently had trouble finding parking in this area, so the Greenwood Commercial Club built a 250-car parking lot just northwest of this intersection in 1947. (Phinney Neighborhood Association.)

This is Greenwood Avenue in the late 1930s looking south toward Sixty-seventh Street where the street curves and becomes Phinney Avenue. Jeanne Sellers's family built a house near North Seventy-ninth Street in the Greenwood area when Jeanne was four years old. Friends of the family asked them why they wanted to live "out in the country." Jeanne's childhood home still stands, and she would "give her eyeteeth" to go in and see it now. Growing up in the 1930s and 1940s, Jeanne remembers the streetcars and the interurban trolley that used to travel from downtown Seattle to Everett. She has watched shops come and go over the years. She remembers when the 74th Street Alehouse used to be Green's 74th Street Tavern. Jeanne and her childhood friends frequented a roller rink at Fremont Avenue and Eighty-fifth Street where townhouses now stand. She recalls a time when the Woodland Park was free of charge. Walking home in the afternoons, she and her girlfriends would stop at the bakery that is now Ken's Market and get an afternoon snack. This was a wonderful neighborhood for kids because of the Woodland Park Zoo, the Rose Garden, and the library. Movies played at the Ridgemont Theater (at Greenwood Avenue and Seventy-eighth Street, where the Bathhouse rehearses now), the Arabian Theatre (on Aurora Avenue between Seventy-sixth and Seventy-seventh Streets) and the Grand Theater (on Eighty-fifth Street near Greenwood Avenue, where Taproot Theatre is now). People held court at soda fountains in such places as Brown's Drugstore and Creamland Restaurant, owned by William B. Fenton. (Phinney Neighborhood Association.)

This man is walking along Phinney Avenue in the twilight sometime in the early 1940s. (Phinney Neighborhood Association.)

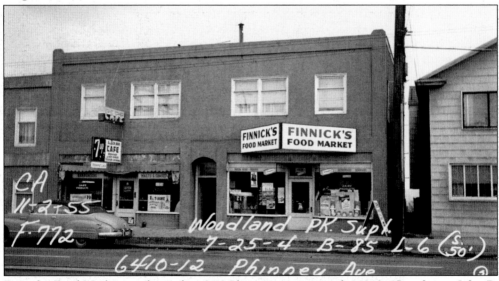

Finnick's Food Market was located at 6410 Phinney Avenue in the 1940s. One former John B. Allen student recalls that the cluster of shops between Seventy-second and Seventy-third Streets boasted a hardware business at least since the early 1920s. In 1948, Ronald and Helen Gowan opened their store at 7318 Greenwood Avenue. Five years later, they moved into the building that still houses Greenwood Hardware. The same block also included a grocery, an automobile repair shop, a barber, a dress maker, a variety store, a candy shop, a bakery, a frozen food store, and a butcher. The Gowans owned the business until 1979. In 1984, the city honored the store as one of the 11 best businesses in Seattle. (Phinney Neighborhood Center.)

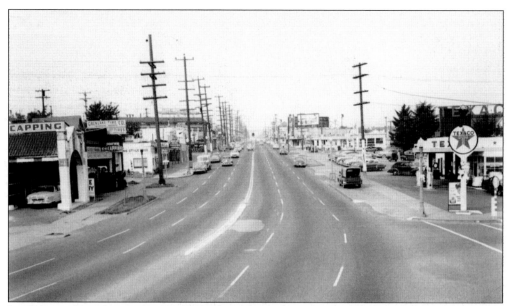

Looking north on Aurora Avenue shows the widening between Sixty-Fifth and Eighty-Fifth Streets in the 1950s. This photograph was taken before the widening was complete. On the corner of Eightieth Street and Aurora Avenue, seen in the photograph, was a Flying A gas station. This building is still preserved. In the 1930s and 1940s, there was a Bartell Drug Store just south of the Flying A and the Chubby and Tubby store (now closed), together with a Safeway store, to serve the pioneers residing out of town around the Green Lake area. (Seattle Municipal Archives.)

The 1950s saw much new construction at the John B. Allen Elementary School on Phinney Avenue, which was needed as the populations of both the Greenwood and Phinney neighborhoods continued to grown. (Phinney Neighborhood Association.)

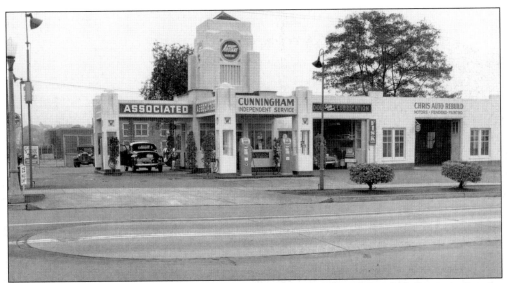

In 1931, Chester E. Jackson and his wife, Emily, lived at 2650 West Eighty-fifth Street in Seattle. Jackson operated a Richfield service station nearby at 2658 West Eighty-fifth Street. This photograph, taken around 1931, shows Jackson's service station with its two tall gas pumps. In addition to Richfield gasoline and other automobile products, Jackson's sold ice cream, tobacco products, and snacks. (Museum of History and Industry.)

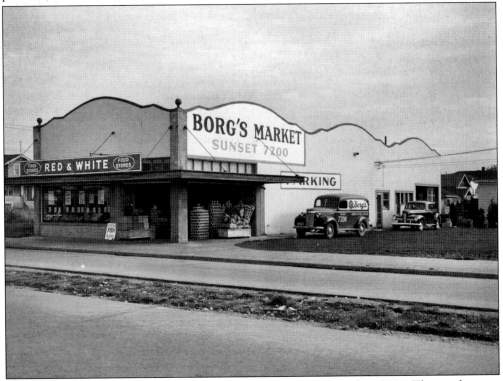

Borg's Market was located at 1111 North Eighty-fifth Street in the 1940s. The market was sometimes referred to as the Red and White Store. Signs advertised fresh fish and sugar at 55¢ for a 10-pound bag. (Museum of History and Industry.)

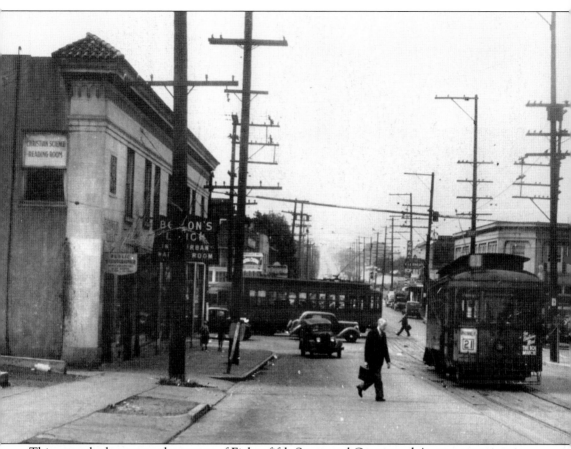

This scene looks west at the corner of Eighty-fifth Street and Greenwood Avenue sometime in the early 1940s. Across the intersection on the right is Brown's Drugstore, and beyond it is the Grand Theater. On the left just before the intersection is a restaurant, which may be Marie's. By now, this area had become a major shopping and commercial area for both the Greenwood and Phinney neighborhoods. (Phinney Neighborhood Center.)

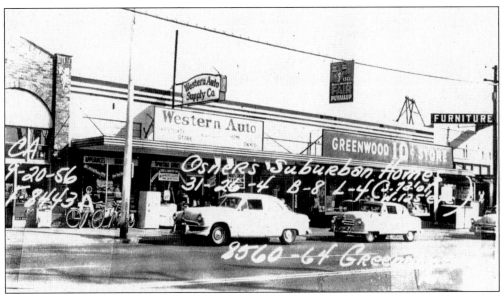

This scene is at 8560 Greenwood Avenue in about 1941. The overhead sign advertises the Puyallup State Fair. We can see a furniture store, the Western Auto Supply Company, and the Greenwood 10¢ Store. The buildings on the stretch of the avenue have remained the same over the years except for the occupants. Since Eighty-fifth Street was the city limit until 1954, there were many more taverns and dance halls in the area than there are today. (Gordito's.)

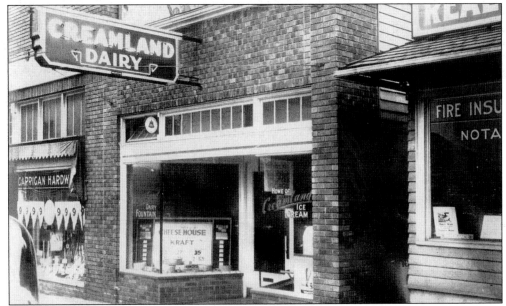

Creamland Dairy, a restaurant owned by William Fenton, was located at 8402 Greenwood Avenue. It was popular with both kids and adults in the 1940s and 1950s. Sandy Brown Hertz recalls, "My girlfriend's dad owned Creamland Dairy on Eighty-fourth and Greenwood, so we would bike over there, have lunch, and get an ice cream cone to eat. When we rode across Eighty-third from Dibble to Greenwood Avenue, we passed the Greenwood Presbyterian church on the corner of First and Eighty-third. I attended that for several years. Now the building is a Buddhist Temple, I think." (Gordito's.)

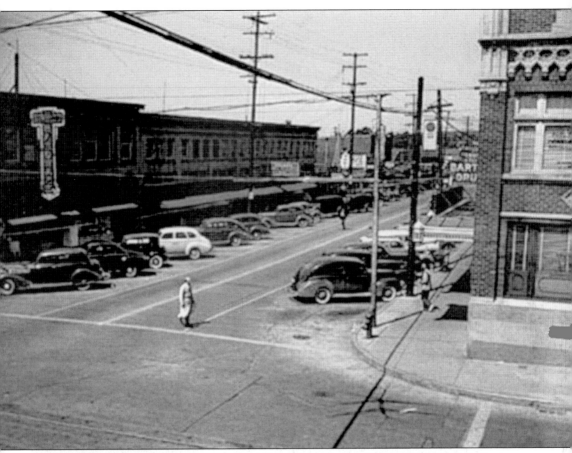

This is Eighty-fifth Street looking east from Greenwood Avenue in 1941. This intersection was a commercial center that marked the north end of Greenwood's Miracle Mile. The intersection at Greenwood and Eighty-fifth, which was annexed by Seattle in 1954, still has many streets without sidewalks. Walking these blocks, the area can still seem to be out in the country. (Museum of History and Industry.)

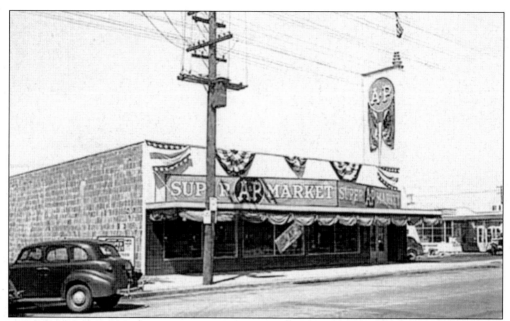

The Great Atlantic and Pacific Market, better known as the A&P, is pictured at Eighty-fifth Street and Greenwood Avenue in 1940. This market replaced a previous lumber company building. The Atlantic and Pacific Company was founded in 1859 in New York by two tea and spice merchants, and was at one time the largest supermarket chain. (University of Washington special collections.)

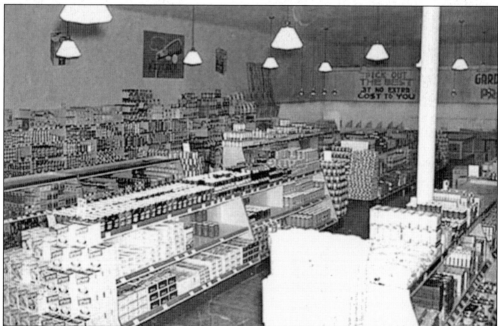

This view is inside the A&P supermarket in Greenwood in the 1940s. Back in the olden days, there were no supermarkets or mega grocery stores. The rows of groceries are neatly arranged, looking not that different from the inside of markets today, except for the prices. (University of Washington special collections.)

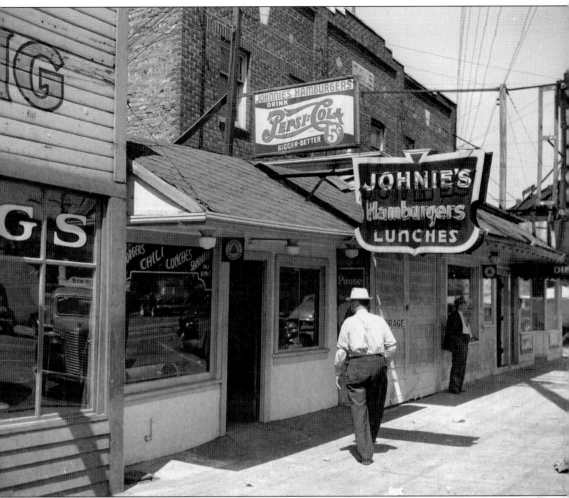

Pictured here are Johnnie's Hamburgers and Verlou's Dine and Dance on Greenwood Avenue just north of Eighty-fifth Street in 1941. This marked Seattle's city limits until 1954. As Greenwood Avenue continued north from this intersection, the shops and services that characterized this growing Greenwood-Phinney neighborhood gave way to bars selling hard liquor by the glass, which was illegal in Seattle, and dance halls and gambling dens that could operate beyond the city limits. These businesses occasionally hosted the Greenwood Boys Club, thus giving local residents an excuse to frequent these shady establishments. (Museum of History and Industry.)

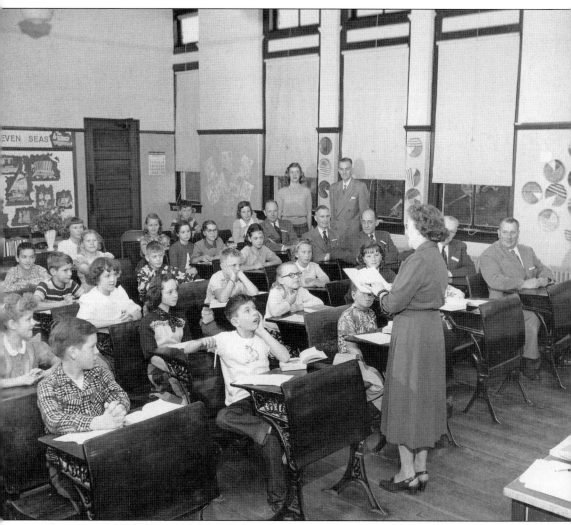

This is inside a Greenwood School classroom in September 1945, based on the date on the wall calendar. The students are obviously impressing their visitors with their work. Sandy Hertz remembers school recesses on rainy days were in the basement of the school with the low ceilings and that the boys' and girls' basements were separate. She also remembers having square dance class with Mr. Burke in the basement in fifth grade. "That memory is clear because my dad was a square dance caller at East Green Lake field house on the weekends, and he would listen to records of calling songs and practice them while getting ready to go for the evening. My favorite was 'O Johnny,' and to this day the only words I remember to that tune are the calls of 'dosey-do your partner; swing that little girl behind you; and a right and left and around the ring.' My brother and I would hang out in the equipment room on the stacks of floor mat exercise mats among the medicine balls and basketballs." (Greenwood Elementary School.)

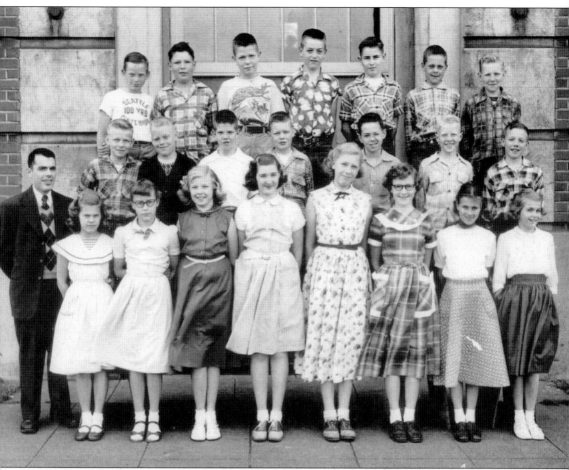

This is the John B. Allen class of 1953 posing for what is probably their graduation picture. Around this time, most elementary schools would graduate their students at the end of the sixth grade, sending them on to junior high or middle schools. (Phinney Neighbor Association.)

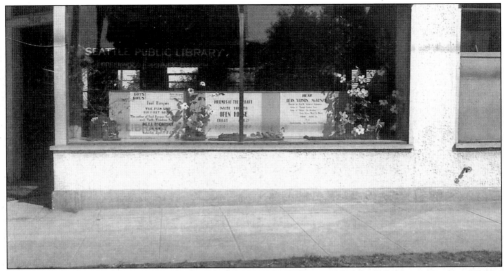

This view looks through the window of the Greenwood-Phinney Public Library in the late 1940s. In 1954, under growing pressure to expand, the library moved to a new location at Eighty-first Street and Greenwood Avenue. It would from then on be called simply the Greenwood Public Library. (Greenwood Public Library.)

This snapshot of the story hour at the Greenwood-Phinney Branch of the Seattle Public Library was taken on April 19, 1950. This popular program continues today, as the children's story hour and takes place in most Seattle branch libraries. (Greenwood Public Library.)

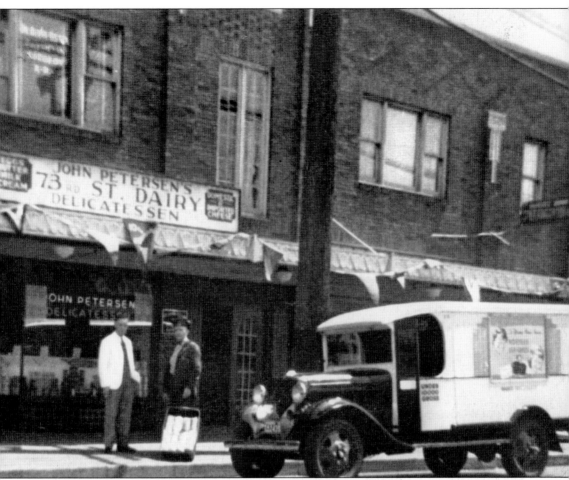

John Petersen's Variety Store was in the 7200 block of Greenwood Avenue and was where kids used to stop after Sunday school at Woodland Park Presbyterian Church and buy ice cream to eat on the walk home. Note the milk truck outside making a delivery. These were the days when milk and dairy products were delivered by VitaMilk in glass bottles. The Golden Rule Bakery truck delivered bread. The fish man came around once a week with fresh fish and seafood. The Fuller Brush man went door-to-door and always gave a free gift, even if you bought nothing. The Watkins man also went door-to-door selling spices and vitamins. The postman came twice a day, once in the morning and again in the afternoon. Those were the days! (Phinney Neighborhood Association.)

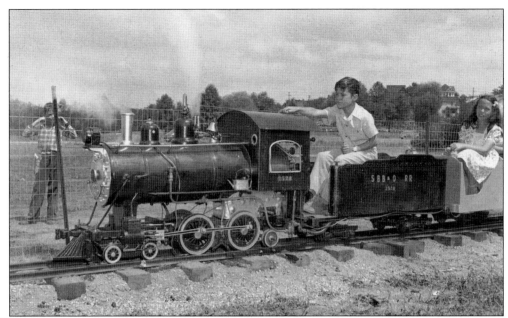

In the late 1940s, many children and teenagers enjoyed riding the miniature train at Woodland Park. Not much is known about the history of this popular attraction. It is unclear how long the Green Lake train ran or whether it continued to run after the Woodland Park Zoo ride concession opened around 1950. This July 1947 photograph shows Clifford Duncan riding on the Green Lake Railroad. He may be blowing the train's whistle, as the boy behind the fence has his fingers in his ears. (Museum of History and Industry.)

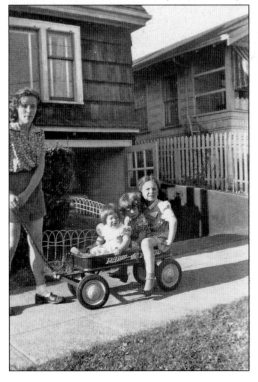

Maryanne Shur, a high school student in 1948, can be seen pulling three Greenwood neighborhood children in a new Radio Flyer wagon, which was probably a birthday present. She often babysat many of the neighborhood kids.

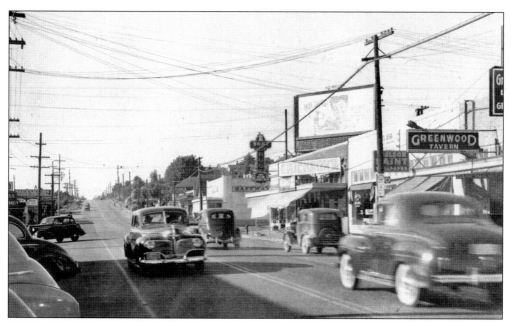

This is Greenwood Avenue in 1942. A John B. Allen student remembers the old Safeway store that was on Seventy-first Street and Greenwood Avenue. The author worked there after it was turned into Brown's Quality Foods. They made those plastic-wrapped pizzas that could be purchased. Plus they made potatoes, macaroni, and coleslaw salads for KFC and other places. (Museum of History and Industry.)

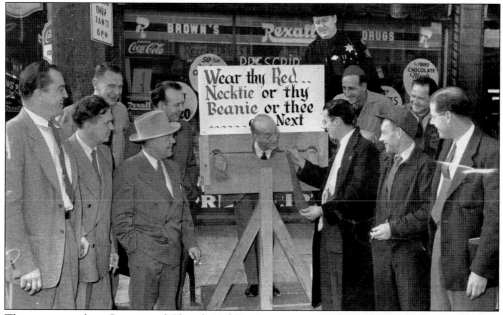

This appears to be a Greenwood Chamber of Commerce event in front of Brown's Drugs at Eighty-fifth Street and Greenwood Avenue in 1949, but what the chamber was promoting is a mystery. Brown's Drugs was a familiar fixture at this location for many years. The author spent one or two afternoons a week searching through the magazines. This is now the site of the Greenwood Academy of Hair and the Paws cat adoption center. (Museum of History and Industry.)

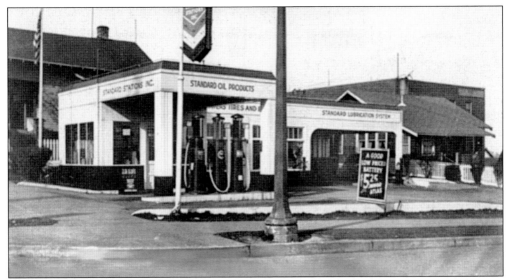

This Standard Oil service station was located at 8315 Greenwood Avenue in the 1940s. Today this site is now occupied by the NW Valet Cleaners. (Greenwood-Phinney Chamber of Commerce.)

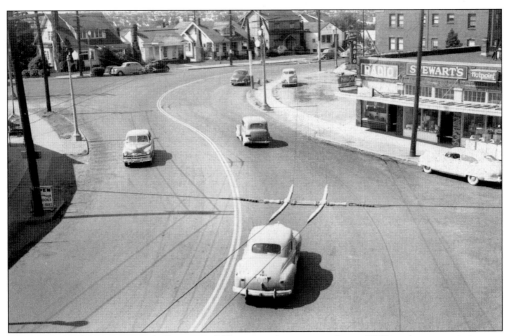

The corner of Sixty-Seventh Street and Phinney Avenue in about 1950 is shown as it curves and becomes Greenwood Avenue. On the right, the radio shop would become today's Red Mill hamburger restaurant, and the house directly ahead continues to look much the same but now is a restaurant. While the architecture of the neighborhood has changed little on the outside in five decades, the businesses themselves are quite different. (Phinney Neighborhood Association.)

This photograph shows the Greenwood-Phinney Branch library on May 13, 1950. Ferne Harris was the branch's first librarian. She staffed the library on Tuesday and Thursday afternoons and evenings and on Saturdays. The Green Lake Branch immediately noted a drop in patronage after the new branch opened, suggesting that Greenwood residents had gone to their new library for their reading. Business was so good at Greenwood that the hours were extended. Demand continued, and in January 1929, Greenwood-Phinney became a six-day-a-week library like the other permanent branches in the city. (Greenwood Public Library.)

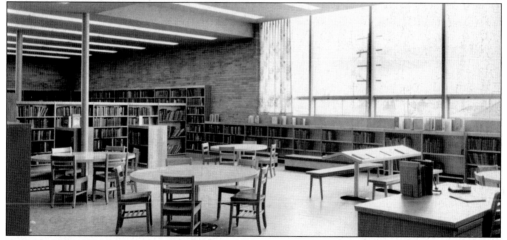

In 1932, University of Washington graduate Luella H. "Lou" Hamilton took over the branch, and she would serve the Greenwood community for the next 30 years. On January 24, 1954, the Greenwood Branch of the Seattle Public Library opened. It was the first new branch built in Seattle in 33 years. Greenwood replaced the Greenwood-Phinney Branch, which had served the community from a rented storefront since 1928. Since shortly after the Greenwood-Phinney Branch opened in 1928, the Greenwood-Phinney Commercial Club and other community groups lobbied the Seattle Public Library Board for a real library. Even though the rented storefront was expanded twice before World War II, the community kept pressing for a larger branch. In 1951, Seattle voters failed to approve bonds for new branches, but the Seattle City Council appropriated reserve funds for construction. (Greenwood Public Library.)

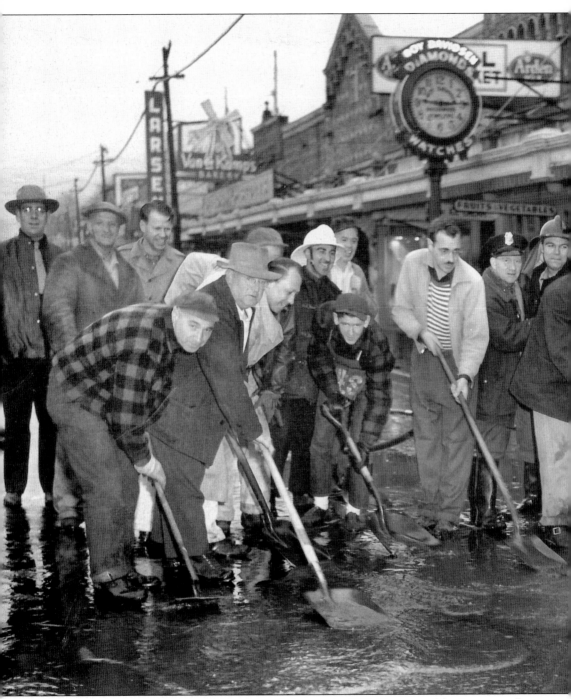

This shot shows men cleaning up Greenwood Avenue in 1947. Greenwood businessman, Boys Club members, and local firefighters work on Greenwood Avenue just north of Eighty-fifth Street in December of 1947. The group hoped to embarrass King County into resuming the street clean-ups that had taken place for more than 20 years. Seattle city limits extended only to Eighty-fifth Street until 1954, and the county cited budget shortfalls in its refusal to continue street cleaning. At the end of World War II, the Greenwood area grew again, and about a third of the housing in

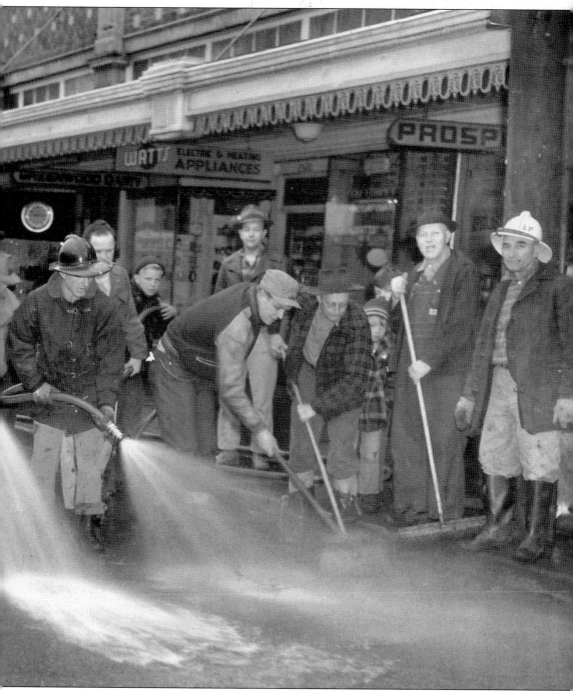

the area reflects the hurried and bland construction of the postwar housing boom. Late in 1952, Greenwood was incorporated into the city of Seattle. At that time, the residents of Greenwood were promised streets, sewers, and other city services if they accepted annexation. A long time passed before the area realized some of these benefits. Not receiving all or most of them is the single most important problem of the Greenwood community. Even in 2007, some streets north of Eighty-fifth Street do not have sidewalks. (Museum of History and Industry.)

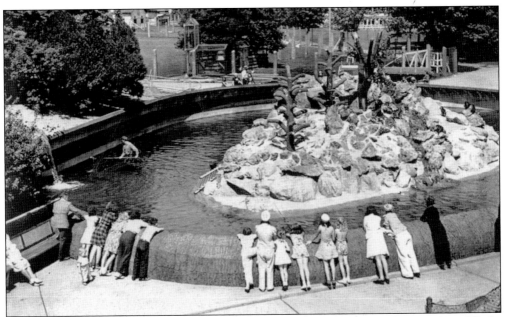

During the economic depression of the 1930s, workers with the federal government's Works Projects Administration (WPA) built Monkey Island and several other animal habitats at Seattle's Woodland Park Zoo. This photograph, taken on a sunny day in May 1946, shows people watching the antics of the monkey colony on Monkey Island at Woodland Park. (Museum of History and Industry.)

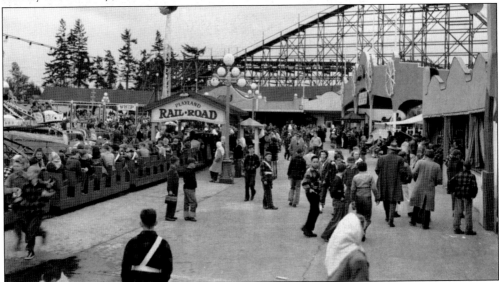

Located beside North Seattle's Bitter Lake was one of the author's favorite places, Playland. Opened in 1930, Playland was an amusement park complete with a giant wooden roller coaster, the Dipper, the largest in the Northwest at that time. Among the rides and attractions was a skating rink with a Wurlitzer pipe organ. A fire destroyed much of the park in the 1950s, but it was rebuilt and continued to operate until 1961. This photograph was taken in 1948 and shows the Greenwood Elementary School safety patrol being given a special Saturday at Playland as a reward. The author was part of the safety patrol and might be somewhere in this picture. (Museum of History and Industry.)

Here are more members of the neighborhood cleaning up in the late 1940s and 1950s. In the photograph below, the author's father gets ready to repaint the house while his younger brother, Kenny, holds the family cat. On the right, two neighbors help one another with house repairs. Many of the homes in this area were built in the 1920s or before. Most are still here but with periodic upgrades. It is a common mark of the community that so many homes have remained.

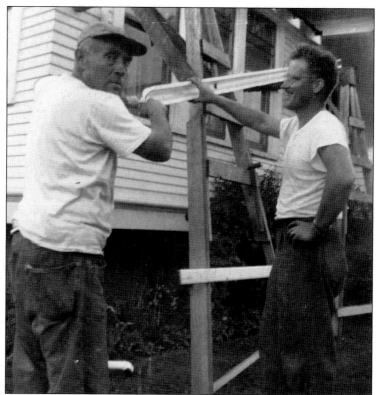

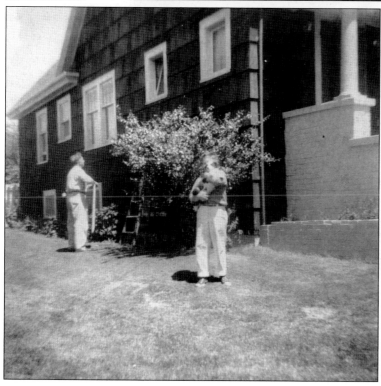

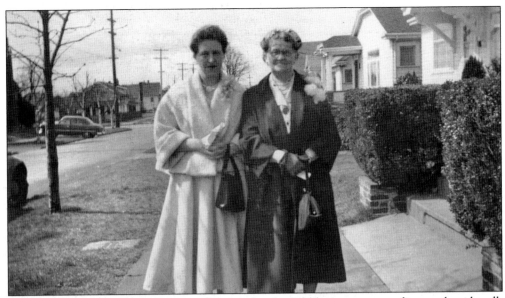

The author's mother, Elna Pedersen, and her mother, Iva Barkley, are seen standing on the sidewalk of Northwest Seventy-sixth Street on a Sunday morning, perhaps pleased with the sprucing up of the neighborhood. Third Avenue is seen in the background. While much has changed over the decades, much remains the same in these family-oriented neighborhoods.

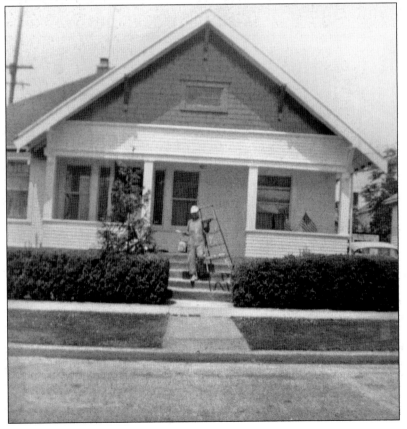

The house in this 1952 photograph is located about three blocks west of Greenwood Avenue at about Eighty-fourth Street and looks almost the same today, over 50 years later, as it did back then.

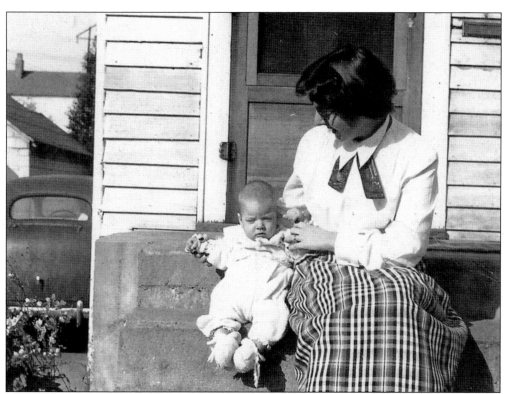

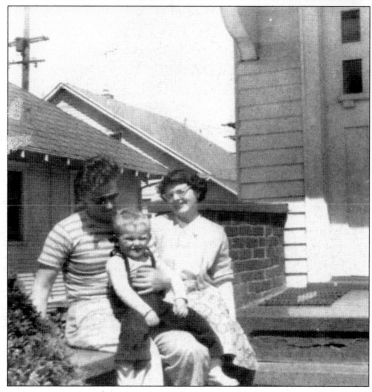

The author's uncle Louis Barkley served in the army during World War II. He returned to Seattle from Germany in 1948 with his new wife, Marylou. After living in a temporary rental apartment for a year, they bought a house a 152 Northwest Seventy-sixth Street, where they still live today. Above Marylou holds her new baby, Bobby. Below, two wars later, she sits on the porch next to Louis with Bobby. In 2006, they celebrated their 60th wedding anniversary.

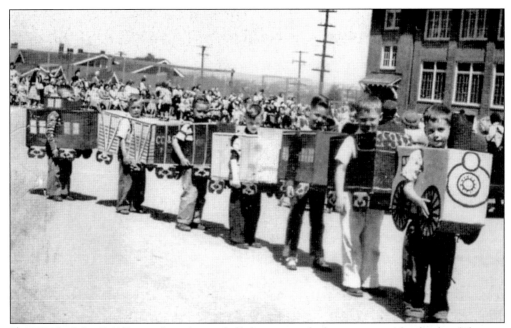

In 1950, the John B. Allen students learned all about trains by becoming one for the day. (Phinney Neighborhood Association.)

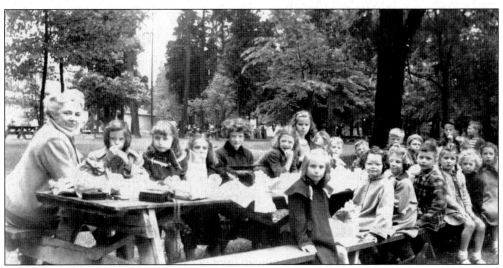

Here the John B. Allen kindergarten students enjoy an outing as they picnic at nearby Woodland Park. (Phinney Neighborhood Association.)

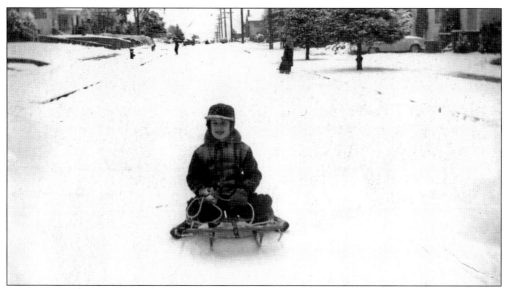

With a mean temperature of 28.7 degrees, January 1950 was colder than the severe winter of January 1916. On Friday, January 13, a blizzard blasted in from the ocean. It continued through the night and into Saturday. The temperature dropped to 11 degrees. High winds lifted the waters of Elliott Bay onto the waterfront, and frozen salt water instantly stuck to anything it splashed. The boy sledding down Seventy-sixth Street enjoys the snowfall.

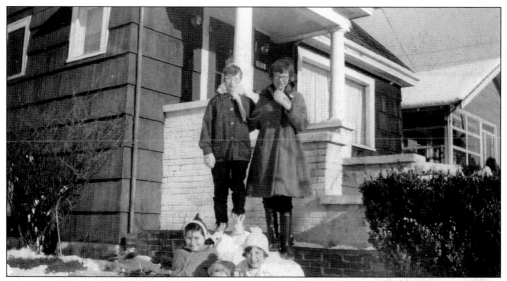

Most of the snow has melted as these kids pose in front of the house at 140 Northwest Seventy-sixth Street, which is where the author lived in those days. Sally Pedersen, the girl standing on the left, is the author's sister. His other sister, Peggy, is in the lower right.

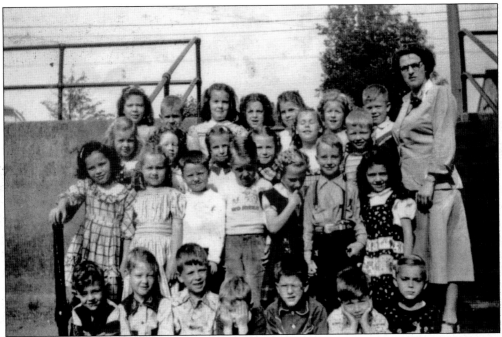

Here are John B. Allen students posing for their 1950 class picture prior to graduation. (Phinney Neighborhood Association.)

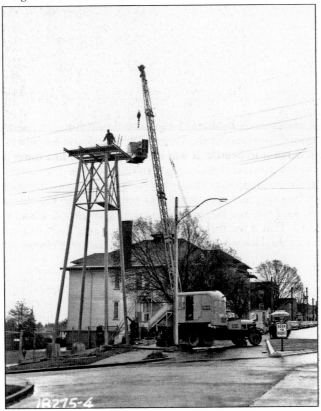

A Chrysler air raid siren was installed on a tower at the John B. Allen School campus. Phinney Avenue can be seen in the background. Every Wednesday, the siren would sound at noon. (Phinney Neighborhood Association.)

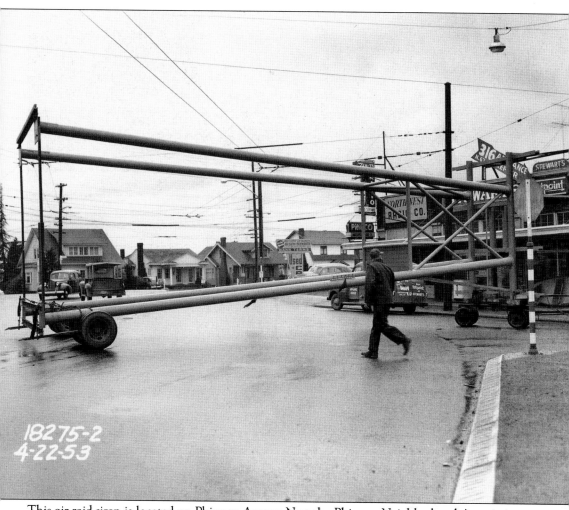

18275-2
4-22-53

This air raid siren is located on Phinney Avenue N at the Phinney Neighborhood Association facility (formerly the John B. Allen School) in Seattle. It was reported to be the first tower of its kind in the country. The tower was prefabricated and brought to this location. The tower is painted green. The siren is in disrepair, and it appears that it has been out of service for many years. The association has recently begun an effort to restore the tower and give the siren a cosmetic makeover. While the siren itself will not be restored to running condition, it and its place in local history will be preserved. This is the first case of preserving a siren in its original location, a noble effort on the part of the Phinney Neighborhood Association. (Museum of History and Industry.)

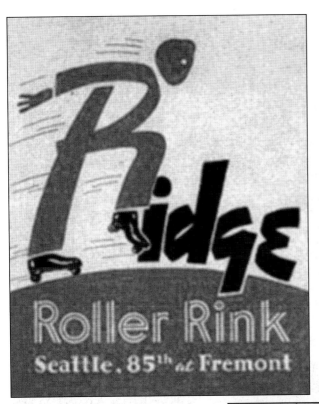

Ridge Rink at Eighty-fifth Street and Fremont Avenue in Greenwood was a popular destination for kids and adults alike. The rink operated as Vance's Ridge Rink and Phinney Ridge Rink. It is not known when each of the names was used. The rink operated from the late 1930s until the 1970s. In 1974, the organ was removed. Its disposition is unknown, although the Judd Walton Opus List indicates that Dave Gentry of Bremerton bought the instrument. Ridge Rink had two Wurlitzer instruments during its operating years. In 1939, opus No. 360, a 2/9 Style 210 was installed. This organ was originally installed in October 1920 in the Winter Garden (Progressive) Theatre in Seattle. This instrument was destroyed in a fire in 1945.

In 1956, this corner of Aurora Avenue and North Ninetieth Street marked what was usually considered the eastern boundary of the Greenwood neighborhood. Just north of Ninetieth would be the home of the Burgermaster Drive-In. Burgermaster has been at this location since 1960. Prior to Burgermaster, the site was occupied by Shadow Towing. The strip center across from the Burgermaster between Ninty-eighth and 100th Streets replaced the former McAlister Motel and Trailer Park. Built in 1985 it started the renewal of this section of Aurora. After it was built, Oak Tree Shopping Center was built with Larry's Market, Starbucks, and Oak Tree Cinema, as well as many other fine stores. The site was previously the site of the Oak Lake School, which had been closed down by the Seattle School District and had become a serious blight along Aurora.

In the late 1940s and early 1950s, it was not unusual to see small kids playing on their own on Greenwood-Phinney's neighborhood streets. Here we see Bobby Barkley enjoying a warm summer day. In the early evening, many more kids would play kick-the-can or hide-and-seek until their parents called them in for dinner.

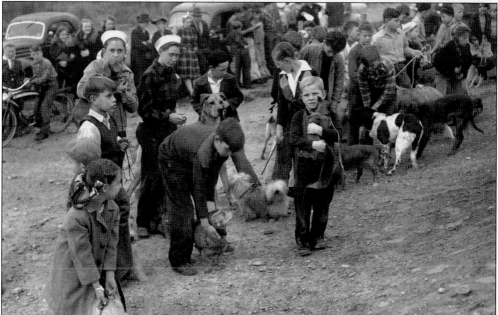

The Greenwood Boys Club dog show in 1944 is pictured. During World War II, Greenwood residents complained about the unruly and unsupervised boys that roamed their neighborhood's streets. After the King County sheriff doubled patrols in the area, the boys complained that they had nothing to do. In 1943, a sympathetic Sgt. Joe Woelfert convinced a local landlord to lease a former nightclub on Greenwood Avenue to the newly formed Greenwood Boys Club. Another property owner allowed the boys to use a vacant lot as a playfield. Crime in the area dropped by 500 incidents in the club's first two years. In 1946, a community fund-raising drive brought in enough money to buy the club a permanent home at 8635 Fremont Avenue. (Museum of History and Industry.)

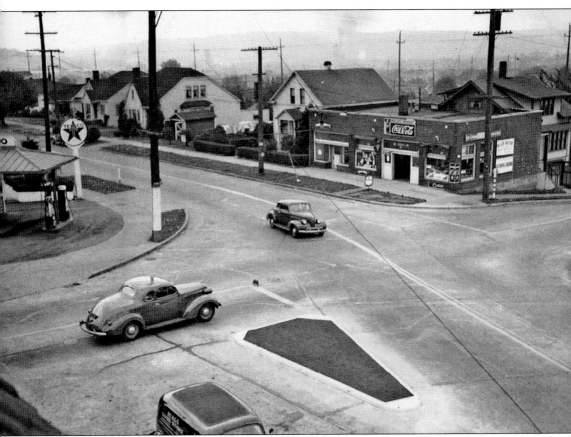

The corner of Third and Sixty-fifth Streets is shown here sometime in the 1950s. At the end of World War II, the area grew again, and about a third of the housing in the area reflects the hurried and bland construction of the postwar housing boom. Late in 1952, Greenwood was incorporated into the city of Seattle. (Seattle Municipal Archives.)

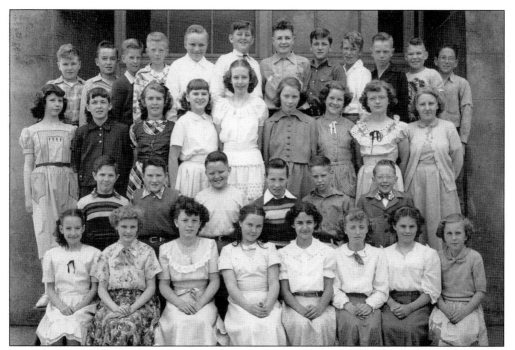

The Greenwood Elementary School sixth-grade class of 1951 poses for their graduation picture. By this time, Greenwood dropped the seventh-grade classes and only went through the sixth grade. The author is standing in the second row, second from the left.

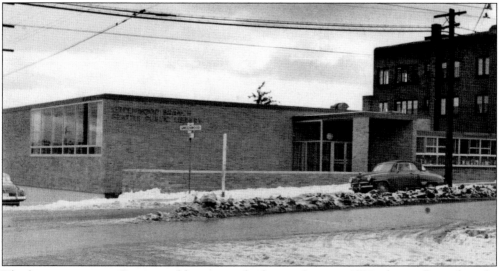

The biggest move in Greenwood history took place in January 1954 when a fleet of trucks transferred 20,000 volumes from the old Greenwood-Phinney Library to the new Greenwood Public Library at 8016 Greenwood Avenue N. Architects Decker and Christenson designed a steel and reinforced-concrete structure. On January 21, 1954, the Greenwood branch opened, and Mayor Allen Pomeroy attended the opening ceremonies, braving snow and ice to make the event. The building featured 9,752 square feet of space (quadruple the size of the old building) and seating for 73 in the reading room and for 100 in the auditorium. It was the first new branch built in Seattle in 33 years. (Greenwood Public Library.)

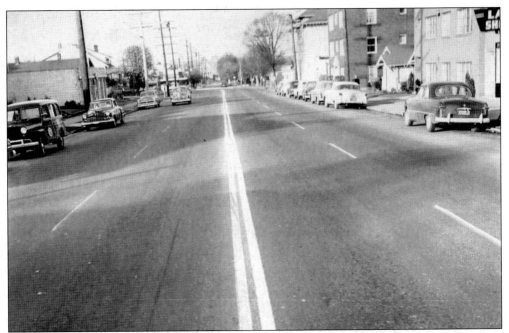

This is Phinney Avenue looking toward the curve where the street turns into Greenwood Avenue sometime in the mid- to late 1950s. The John B. Allen Elementary School is at the top of the photograph on the left. The houses, stores, and apartments remain much the same today. (Phinney Neighborhood Association.)

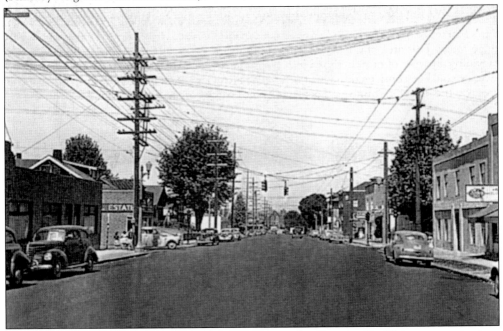

Looking north on Phinney Avenue, new lines were painted to direct traffic. This area running into Seventieth Street and Greenwood Avenue has had an ever-changing parade of stores and businesses over the years. In the words of one former John B. Allen student, "remember the old Safeway store that was on Seventy-first and Greenwood?" (Phinney Neighborhood Association.)

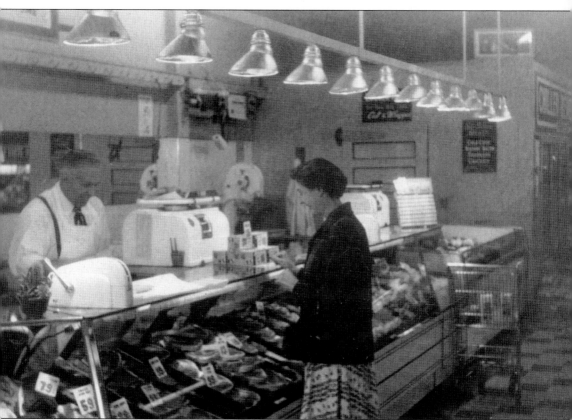

Ken's Market at 7231 Greenwood Avenue opened in 1955, replacing another market, and is still there today. This area of Greenwood was a mini shopping mall during the 1940s and 1950s, providing all types of neighborhood services. If the area at Eighty-fifth Street and Greenwood Avenue could be considered the major shopping area for those living in Greenwood, then this area was the same for Phinney residents. (Phinney Neighborhood Association.)

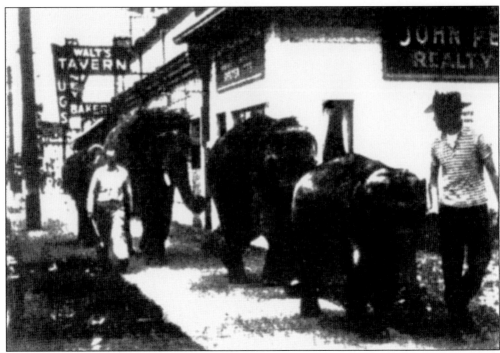

On May 23, 1958, Jolene Lechelt Rod was in the sixth grade and on patrol at the John B. Allen Elementary School. It was lunchtime, and the author was stationed on the island in front of the wooden building when a truckload of elephants tipped over as it rounded the corner heading south on Phinney Avenue. It was quite the experience watching the handlers unload those elephants, line them up on the sidewalk, and walk them back to Woodland Park Zoo. In the picture below, one can imagine the elephants safely back home.

Four

SEEKING AN IDENTITY

Today Greenwood is a Seattle neighborhood with an active commercial core. It is a destination for art and for antiques shops that run along Greenwood Avenue N. The North Eighty-fifth Street and Greenwood Avenue N intersection is still the heart of the neighborhood, a crossroads where banners are hoisted to highlight the Greenwood-Phinney Art Walk in May and the Greenwood Classic Car and Road Show in June. Residents, too, are an eclectic mix. Senior citizens mix with young families new to the area, and a new, low-income housing complex sits blocks from a custom-built upscale home. Much of the original housing stock is now gone, but what remains are brick ramblers, old Tudors dating to the 1930s, bungalows, and split-levels from the 1960s.

Phinney Ridge is not for the short-tempered. People who live there are sometimes kept awake by wolves howling at a full moon or monkeys hooting and yelping at the Woodland Park Zoo. The noises are so loud they have been heard as far away as Queen Anne Hill. "You never know what sets them off. You know monkeys," says Jim Westling, a Phinney Ridge illustrator who says his kids love the zoo noise. "How many places can you live and hear monkeys other than Africa?"

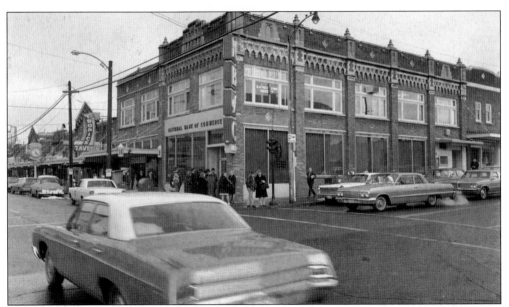

The National Bank of Commerce was located at Eighty-fifth Street and Greenwood Avenue in 1969 when this photograph was taken. This was originally the Greenwood Bank and later the Seattle First National Bank, which was taken over by Bank of America. It seems that there was always been a bank at this corner. Nearby are the Tropics Tavern, the Greenwood Restaurant, and many other small shops. There was also a Fuji Dime store on the block. Note that the large clock is still there today. (Museum of History and Industry.)

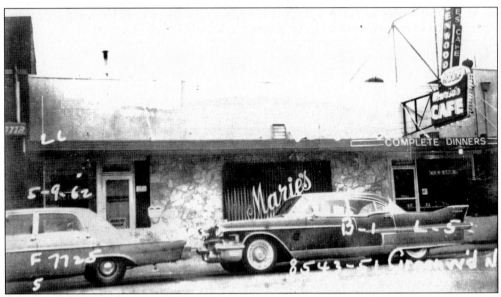

Marie's Cafe was located at 8543 Greenwood Avenue on June 9, 1962. This restaurant was originally at the northeast corner of Eighty-fifth Street and Greenwood Avenue. It was replaced by a Jackens Restaurant and then moved to this location until it closed. Baranoff's restaurant took its place and is still going strong 26 years later. While Marie's may be gone, she remains in the memories of many longtime Greenwood residents, and her popular salad dressing can still be found in most grocery stores. (Gordito's.)

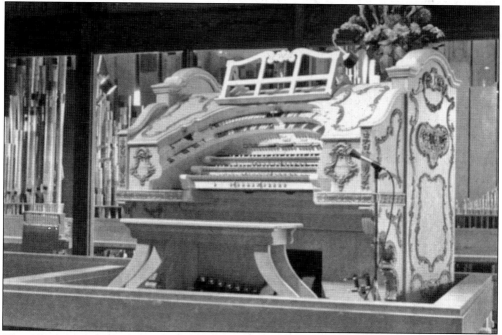

The Greenwood Pizza and Pipes Wurlitzer was originally installed in July 1930 in the Paramount Theatre in Salem, Massachusetts. In 1973, the instrument was purchased by pizza organ magnate Bill Breuer for installation in the Greenwood Pizza and Pipes restaurant. Pizza and Pipes was closed in the late 1980s. The instrument was purchased by Jerry Gould, who has it installed in his Maple Valley barn studio. A Jolly Troll restaurant took the place of Greenwood Pizza and Pipes and has since been replaced by Blockbuster Video and Bartels Drugstore.

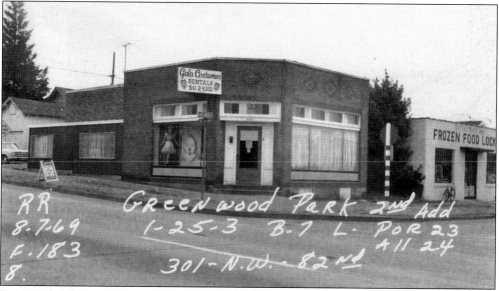

In 1969, the old grocery story at the corner of Eighty-second Street and Third Avenue had been transformed into Gala Costumes Rentals. Just down the block is the Frozen Food Lockers where local residents could store large quantities of meat at a time when most houses did not have large freezers. (Phinney Neighborhood Association.)

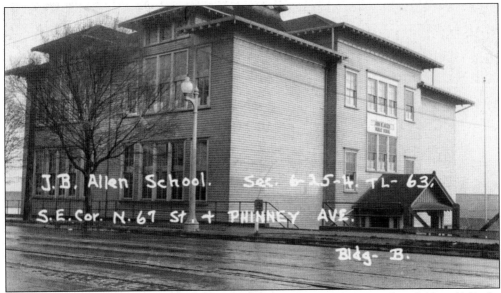

This photograph shows the John B. Allen Elementary School as it appeared in the late 1960s. In a few more years, it would close as a school and become the home of the Phinney Neighborhood Association community center. (Phinney Neighborhood Association.)

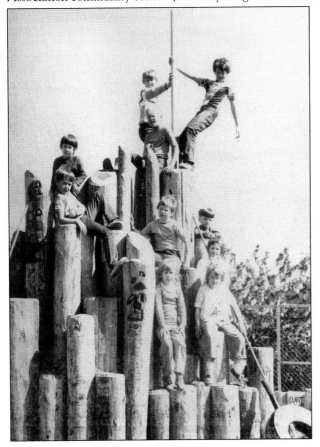

The kids were enthused about their custom-made Log City play structure, which opened in 1981. "We made this playground," eight-year-old Marshall Brekke shouted from the tower of logs, which recently appeared on the grounds of the John B. Allen Elementary School "It's more climbable than the one at Woodland Park because we designed it," beams Lisa Hale, a fifth grader. Because of the remarkable spirit of cooperation among teachers, parents, and students at the school, creative projects have been accomplished at a minimal cost with satisfaction to all. (Phinney Neighborhood Association.)

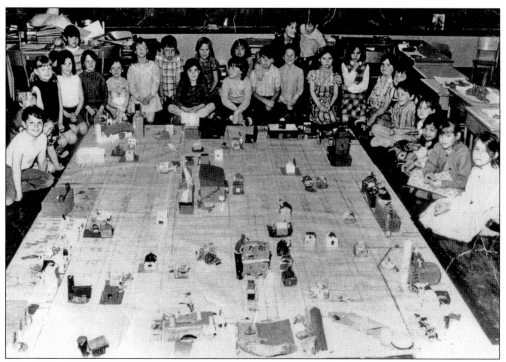

John B. Allen kids learn all about their Phinney Ridge community as they construct this large map of the neighborhood in 1971. (Phinney Neighborhood Association.)

At the corner of Phinney Avenue and Sixty-fifth Street are several small businesses, including Mae's Café. Francine Barr grew up in Phinney Ridge in the 1950s and 1960s. Her grandmother's house near Sixty-fifth Street and Phinney Avenue still stands. On one side, it has a green arbor covered with pink roses in the spring. She remembers crossing the street by herself for the first time from where Mae's Café is now. She remembers going to the Woodland Park Zoo when it was free of charge to watch the zookeepers feed the animals in the mornings. Francine's grandmother bought her stove at the Hotpoint store where Starbucks and Red Mill Burgers are now. (Phinney Neighborhood Association.)

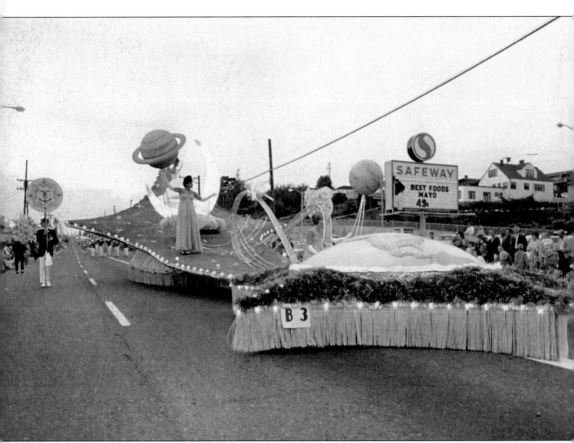

This is the Greenwood Seafair Parade in the summer of 1964. In this photograph, the parade is moving south along Greenwood Avenue toward Eighty-fifth Street. There was a Safeway supermarket in the same location where it is today. This sign is visible, but the parking lot and market are off to the right. Note the large white house at the top right, which was a funeral home. (Museum of History and Industry.)

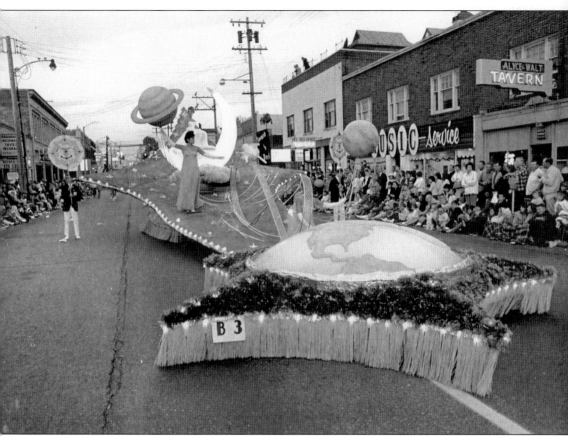

The same 1964 Greenwood Seafair parade has turned the corner and is now moving west on Eighty-fifth Street. On the left, past the Greenwood Avenue intersection, the National Bank of Commerce is visible, and farther up is the A&P market. On the left on this side of Greenwood Avenue is Brown's Rexall Drugs, and closer and unseen is the Grand Theater. On the right is Alyce and Walt's Tavern and a Music Service store. Gordito's Restaurant is now in this area, probably where the sign reads Peg and Geo Office Tavern. It would seem the office was upstairs and the tavern below. (Museum of History and Industry.)

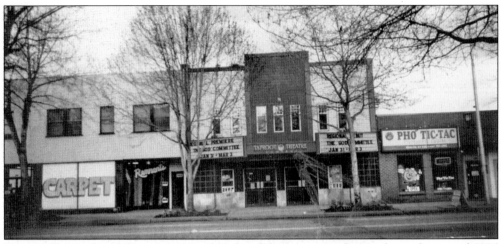

Taproot Theatre bought its current in 1988, but did not start producing shows there until 1996 because of the need for renovations. The building, which opened as a family theater in the 1920s, needed new wiring, flooring, plumbing and interior walls. "It was a massive undertaking," says managing director Sean Gaffney. The opening season was twice delayed. Gaffney lives around the corner from the theater in an apartment above Romio's Pizzaria, and he has come to love this place he calls home.

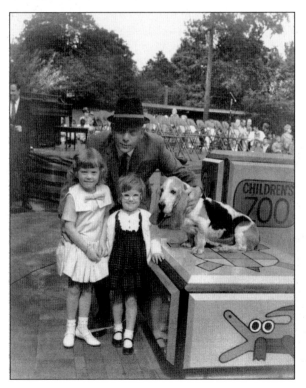

In 1960, a city bond issue was passed that allocated money for the construction of a children's zoo at Woodland Park, a new reptile house, and a small mammal building. For several years, the park board debated about whether or not the children's zoo should be a sort of storybook land with exhibits based on nursery rhymes and fairy tales. However, this approach was abandoned in favor of a less fanciful one designed by architect Fred Bassetti. Constructed in three stages, work began in 1966, and the Children's Zoo would eventually be renamed the Family Farm. In this photograph, popular television star Stan Boreson welcomes the kids to their special zoo. (Woodland Park.)

This photograph shows the kids at Woodland Park enjoying the old Caterpillar Ride in the 1960s. (Julie Albright.)

The corner of Sixty-second Street and Phinney Avenue is now Sully's Snowgoose Saloon. It was once the La Boheme tavern. A patio has been added, but the more things change the more they remain the same.

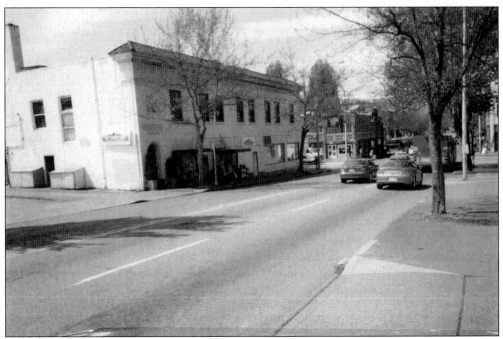

This image shows Greenwood Avenue and Eighty-fifth Street in the 1990s. The buildings remain, but Brown's Drugs is now the Greenwood Hair Academy and Paws cat adoption. Farther down on the right is a new coffee house and the Taproot Theater.

This building at the corner of Sixth and Seventy-seventh Streets NW was once the workroom of Elna's Custom Draperies in the 1950s. This business was owned by the author's mother and remained in this location until the late 1960s when she moved to a new, larger location on nearby Crown Hill. Across the street there was a grocery store and down the block a shoe repair shop. Up until the 1960s, many small mom-and-pop stores occupied these few blocks.

This air raid warning tower was built during World War II when Japanese air raids were thought to be a danger to the city of Seattle. The siren remained in use throughout the Cold War, and every Wednesday at noon the horn blasted for two to three minutes. It still stands at Phinney Neighborhood Center and is possibly the only one of the original Chrysler sirens that remains today.

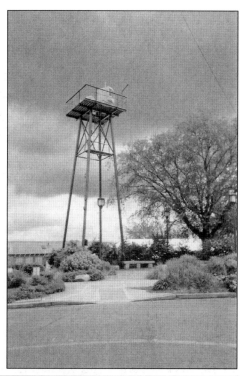

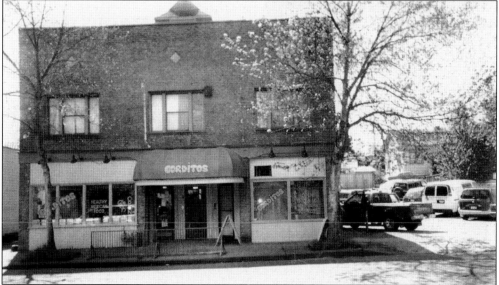

Marlene Hall and her husband, Gabriel Ramirez, started small when they opened their first business on North Eighty-fifth Street after moving here from Hawaii. They called their restaurant Gordito's, a backhanded tribute to their 10-year-old son Shannon, and they served up healthy Mexican food in a space so modest it could accommodate only six tables. In 2006, Gordito's moved to more spacious digs across the street, but there are still lines that stretch from the cash register, where Hall greets and chats with all the regulars, clear out the door. "This is like a small town in the middle of the city," Hall says of the neighborhood where she does business. "I have to watch what I buy at the market and how I behave in public."

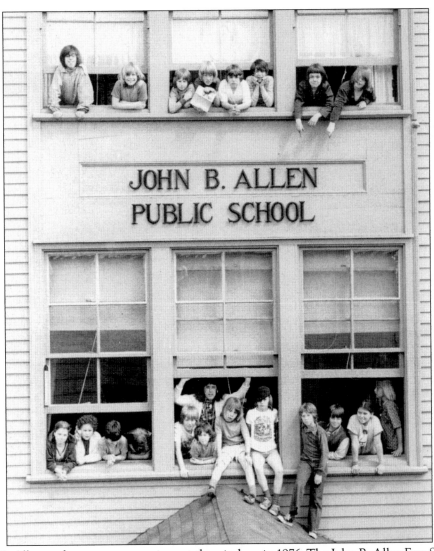

John B. Allen students are seen peering out the windows in 1976. The John B. Allen Free School began in fall 1972 with 44 pupils in grades four and five in a portable classroom called "Allen's Alley" next to the lower building. The goal of the Allen Free School was to give each child an opportunity to decide what course of study to follow. Three years later, the alternative program had moved to the upper building and was operating as a kindergarten through fifth-grade facility with 108 students and 4 teachers. In 1977, the Allen Free School evolved into the Allen-Orca Alternative School for grades kindergarten through fifth. By fall 1980, Orca had a waiting list of 70. Faced with a combination of declining enrollment and decreasing federal resources, plus a building considered unsafe in the event of an earthquake, the district closed Allen School after the spring of 1981. At the time, Allen had 105 students in the regular program and 165 in Allen-Orca. Regular program students were reassigned to B. F. Day, Bagley, Greenwood, and West Woodland schools, while the Orca program was moved to B. F. Day. Both the upper and lower buildings have been leased to the Phinney Neighborhood Association since the fall of 1981 for family and community activities. Current uses of the two buildings include a preschool co-op, childcare centers, and community meeting space. In September 1981, the school became the Phinney Neighborhood Center. (Phinney Neighborhood Association.)

This A-1 Piano Sales and Rentals store occupies the building where the 1928 Greenwood-Phinney Library was once located before moving to its present location in 1954. The interior appears much the same as it previously did, except pianos now replace books.

More than 50 years after opening, Ken's Market is still going strong today. As they did then, many Greenwood and Phinney residents continue to shop in this neighborhood shopping area.

The intersection of North Eighty-fifth Street and Greenwood Avenue is the heart of the neighborhood. Many of the brick storefronts look as they did in the 1920s, a little worse for wear but charming nonetheless. They are occupied by an eclectic mix of merchants, selling everything from antiques and collectibles, to comic books and clothes. The upper floors frequently are leased out as apartments.

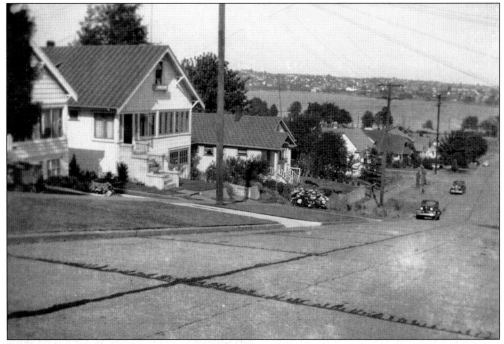

This view is looking down Sixty-seventh Street toward Green Lake. This is the view that must have attracted many early residents to the area. Walking down the lake can be a pleasant experience, especially in nice weather, but the hike back up the hill can be a bit tiring.

With towering windows bringing in natural light and energy-efficient heating, Seattle's Greenwood Elementary is among a growing class of cutting-edge, high-performance buildings. A $15.7 million renovation the school completed in 2002 brought the aging building up to 21st-century standards by using an emerging federal government standard to save energy, use more recyclable building materials, and make the building more efficient and user friendly.

The Baranof Lounge is, in its way, a reflection of its neighborhood. The area around Eighty-fifth Street and Greenwood Avenue appears to be cobbled together from odd leftover bits of other places even as the condos and big box buildings begin to crowd around like bullies at a playground fence. The lounge opened 26 years ago where Marie's Cafe had been and remains a popular eating-out spot.

This new apartment building stands in the location where Safeway was located in the 1940s and 1950s, across the street from the old Greenwood-Phinney Library.

Leilani Lanes ended its 44-year run in November 2005 on a bitter note—with waitresses and bartenders at the Greenwood Avenue landmark caught in a fight between their union and the owners that cost them health insurance. It was obvious the end was near. Its awning was already torn and hung limply on one side. Inside the bowling alley was a fading throwback to the 1960s. Bowlers were greeted by a pink-mouthed tiki mask, a Lustre King ball conditioner by the raised counter, and rows of aging Brunswick lockers. When it closed, the bowling alleys were moved to Ballard's Sunset Bowl.

This house just west of Greenwood Avenue on Seventh Street N was originally built in 1909, making it one of the oldest residences in the area. Improvements have been made to the house over the years, and a garage has been added, but it looks almost the same as did just after the beginning of the 19th century.

This picture shows the corner of Eighty-fifth Street and Greenwood Avenue as it looks today. This area remains the heart of the neighborhood.

The corner of Seventy-third Street and Greenwood Avenue is often considered the heart of the Greenwood shopping area for residents of Phinney and Greenwood south of Eightieth Street. Many shops have come and gone over the years. There used to be a drugstore on the corner, and in the middle of the block is Santaro's Books, while a used bookstore is just across the avenue. There was also a Horse Meat Market for short period back in the late 1940s.

This building was once occupied by a small mom-and-pop grocery store at the corner of Seventy-second Street and Third Avenue. Today it appears to be a private residence.

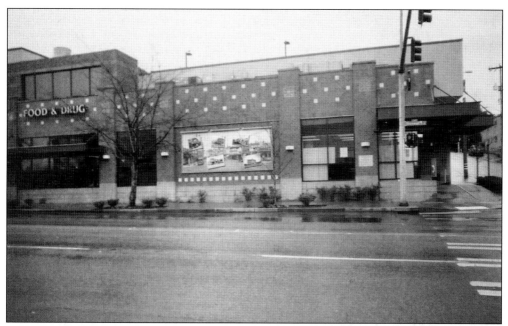

The Greenwood-Phinney neighborhood has had a Safeway store for many years, and for over 40 years, one has been located at Eighty-seventh Street N and Greenwood Avenue. Of course, this store is much larger than the original that was here in the 1960s.

For 15 years, the Greenwood Classic Car and Rod Show has attracted more than 20,000 visitors to Greenwood Avenue every summer. During the event, this street is filled with hundreds of antique cars for more than 30 blocks. One of the biggest showcases of cars across the Northwest, bands, food vendors, and craft booths line the streets of Greenwood Avenue from North Seventy-second to North Ninetieth Streets. The show is free and open to the public.

When passing by the south end of Woodland Park, a piece of the notorious American battleship the *Maine* is hidden in plain sight. Scrap metal from the *Maine*, melted into a plaque, is affixed on the base of the *Hiker* statue, the most prominent artifact in a park parcel that began as a Spanish-American War Veterans Plot. The *Hiker* honors fallen soldiers in that war, which ended 100 years ago in December 1898, as well the Philippines Insurrection and the China Expedition.

The corner of Third Avenue and Sixty-fifth Street is shown as it looks today. There have always been a few small businesses around this location and farther down on Sixty-fifth, including the old Woodland Theater.

The Phinney Ridge Lutheran Church at 7500 Greenwood Avenue has been serving the community in this same location for many years.

The Home Espresso repair shop resides at Sixty-fifth Street and Phinney Avenue today. In the 1930s, it was the Cottage Real Estate office. The building, like so many others in the neighborhood, looks very much the same today as it did then.

Pete's Egg Nest on Greenwood Avenue near the corner of Seventy-eighth Street is a popular neighborhood breakfast place across the street from the condominiums that had been the former Ridgemont Theater. And complimenting it next door is the new Gorgeous George Mediterranean restaurant, serving lunch and dinner.

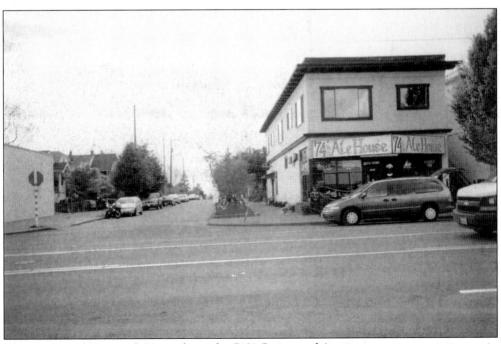

The popular 74th Street Ale House, located at 7401 Greenwood Avenue, was once a grocery store in 1910. The building has undergone many changes over the years until its current reincarnation.

The Ridgemont Condominiums have replaced the old Ridgemont Theater. The Ridgemont operated as one of the first foreign movie theaters in the area. The Ridgemont Theater building at Greenwood Avenue and Seventy-eighth Street was razed and replaced with a four-story, mixed-use building that includes 21 condominiums, 2,400 square feet of retail space, and underground parking for 36 vehicles.

Greenwood Hardware is a neighborhood fixture on the corner of Seventy-Second Street and Greenwood Avenue N in Seattle. For nearly 60 years, the store's reputation has been based on courteous and knowledgeable employees who place the customer first. The store was originally founded in 1948 by Ron and Helen Gowan, who ran the business until 1977 when it was sold to Ron and Robyn Lewis. In 1978, Greenwood Hardware became a member of the True Value buyer's cooperative and has since done business as Greenwood True Value Hardware.

Fire Station No. 21 has been at the corner of Seventy-third Street and Greenwood Avenue N for five decades. A boxy building with the look of a 1950s rambler, it is not any bigger than most of the businesses that surround it on the busy street that connects the Phinney Ridge and Greenwood districts.

The Diva Espresso coffee shop at the corner of Eightieth Street and Greenwood is the author's favorite in the Greenwood area. Behind it is the Greenwood Masonic Temple that has been there since 1924, considerably longer than the coffee shop.

The new Greenwood Public Library at 8016 Greenwood Avenue N opened January 29, 2005. It is the 13th project completed under the Libraries for All building program. The $6,924,627 project replaced the former building, which featured more than 7,000 square feet of space and an auditorium. The new branch has an expanded collection capacity of 66,700 books and materials, including material in Spanish, Russian and Vietnamese. It also planned to increase Chinese materials. The branch has soft, comfortable seating for children, a special area for teens, 38 public computers, underground parking for 36 vehicles, and a meeting room that can be reserved for community use.

The Norse Home Retirement Community recently celebrated 50 years of proud heritage and tradition, and looks better than ever in 2007. Founded by members of the Norwegian American Community, the Norse Home opened in June 1957. The building is an impressive Seattle landmark on Phinney Ridge across the street from the Woodland Park Zoo.

The Sakya Monastery, located at Northwest Eighty-third and First Streets, is the only Tibetan Buddhist monastery in the United States; the Sakya Monastery of Tibetan Buddhism is a little-known treasure in Seattle. The head lama of the Sakya Monastery is only third in rank below the Dalai Lama himself. Founded as a Tibetan monastery in 1975, the monastery is a brightly painted building decorated with intricate carvings and red and yellow colors. Sakya Monastery was featured in the 1993 film *Little Buddha*. The Sakya Monastery of Tibetan Buddhism was home to the Tibetan lama Dezhung Rinpoche (1906–1987), who arrived in Seattle in 1960 after being forced to flee his Communist-occupied homeland. A white stupa outside the monastery is built in his honor. The exterior alone—complete with prayer wheels covered in Tibetan script—is worth a visit, but several times each week, the public is welcomed in for meditation. The interior features beautiful statues, meditation rooms, and a library.

Woodland Park Presbyterian (WPPC) is a church that is committed to the expression of Christian faith and the spiritual growth of its community and its members. WPPC does this with an innovative children's program, active outreach programs, and a commitment to individual spiritual growth.

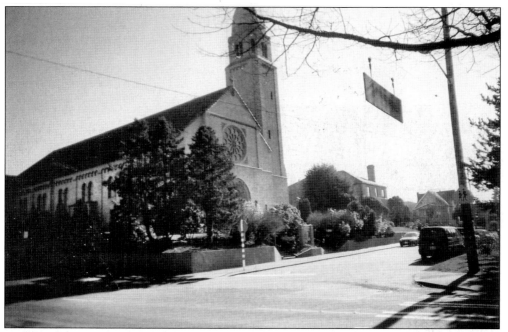

St. John the Evangelist Catholic Church at 121 North Eightieth Street and its school have been here since 1923. The school is a neighbor of Greenwood Elementary, and both share safety patrol duties.

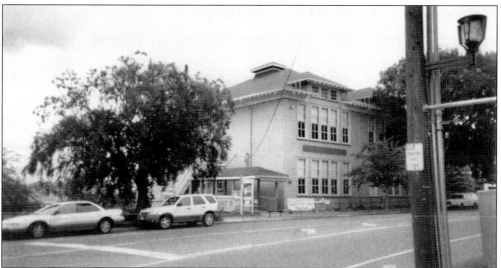

The buildings that make up the Phinney Neighborhood Center have been serving the community since 1904 when the wooden building opened as the John B. Allen Elementary School, part of the Seattle School District. The two-story building was named for one of Washington's first senators and housed 278 students at the end of its first year. In 1917, the district opened the brick building and enrollment increased, peaking at 758 in 1933. The school closed in June 1981 and opened again in September 1981 as the Phinney Neighborhood Center. Over the years, the Phinney Neighborhood Center has become the focus of Seattle's Greenwood-Phinney neighborhood, offering a wide variety of programs and activities for the whole community, with a particular emphasis on programs for children and families, and education.

ACROSS AMERICA, PEOPLE ARE DISCOVERING SOMETHING WONDERFUL. *THEIR HERITAGE.*

Arcadia Publishing is the leading local history publisher in the United States. With more than 4,000 titles in print and hundreds of new titles released every year, Arcadia has extensive specialized experience chronicling the history of communities and celebrating America's hidden stories, bringing to life the people, places, and events from the past. To discover the history of other communities across the nation, please visit:

www.arcadiapublishing.com

Customized search tools allow you to find regional history books about the town where you grew up, the cities where your friends and family live, the town where your parents met, or even that retirement spot you've been dreaming about.